Maxfield Parrish

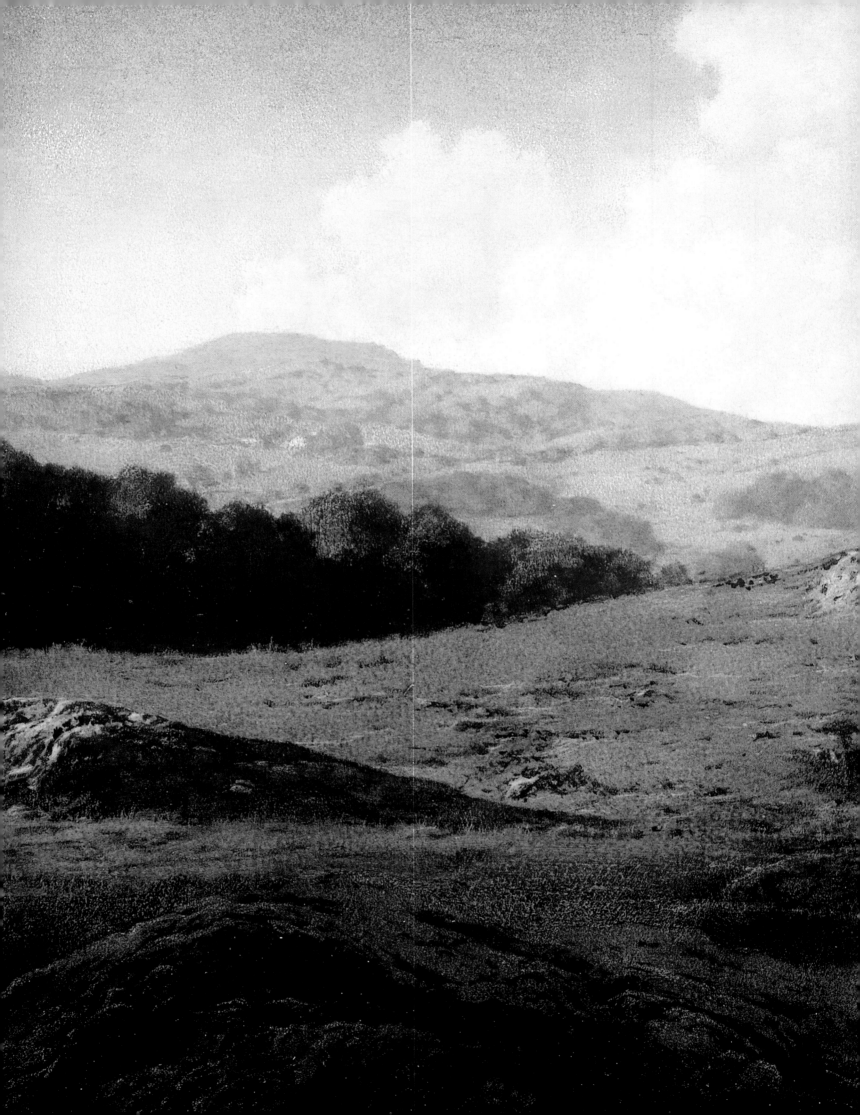

Maxfield *Parrish*

Laurence S. Cutler AIA RIBA
Judy A.G. Cutler

The National Museum of American Illustration

GRAMERCY

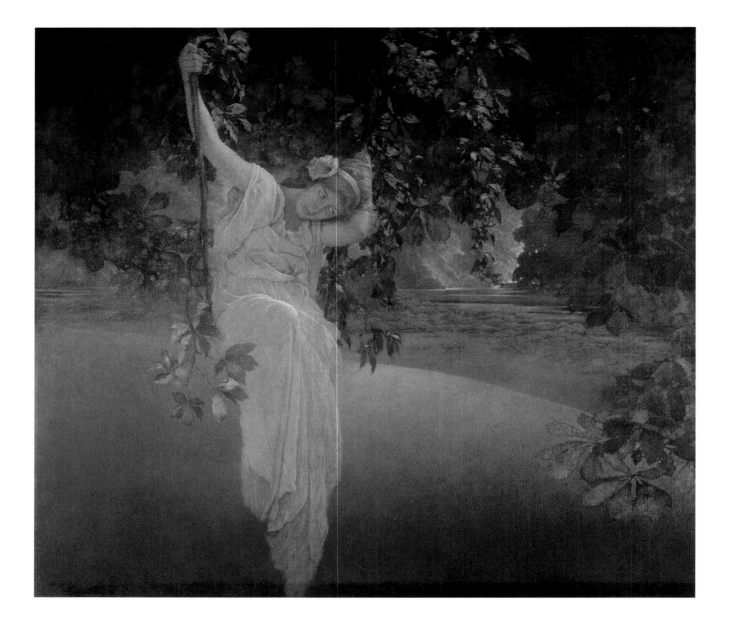

This 1999 edition is published by Gramercy Books™, an imprint of
Random House Value Publishing, Inc., 201 East 50th Street, New York,
NY 10022

Gramercy Books ™ and design are trademarks of Random House Value
Publishing, Inc.
Random House New York • Toronto • London • Sydney • Auckland
http://www.randomhouse.com/

Printed in Singapore

ISBN 0-517-16122-2

10 987654321

List of Plates

AUTHOR'S ACKNOWLEDGMENTS

There are already a number of books available on Maxfield Parrish including several by these authors. However, for many years, Coy Ludwig's seminal work *Maxfield Parrish* (1973), was the only book available of any consequence. The Ludwig work was originally prepared as a doctoral dissertation for submittal to Syracuse University. Some time after Ludwig's thesis was submitted and the degree awarded, he was appointed to the Syracuse Fine Arts Department faculty. Since Coy Ludwig's comprehensive book was first published, some twenty-five years ago, we have co-authored three Parrish books and a number of art exhibition catalogues which were released in the United States as well as in Japan, Italy, and France.

Our first book on Parrish (1993) was published exactly twenty years after Ludwig's work and included images not previously known. Likewise, this book comprises many images never published before. Our Parrish research has continued intensively and often we are asked to share our findings with others just as Ludwig shared his thesis over the past decades. Consequently, we feel that our primary acknowledgement should be to Coy Ludwig for his early efforts and in-depth research into the life and work of this great artist-illustrator. Without his initial investigative studies as a graduate student, many of us would not have delved into the intricacies of this great art, the unique painting techniques employed or this artist's fascinating life. Much valuable information would have been lost forever and for this we thank him.

The late Maxfield Parrish Jr. was the executor of his father's estate. Because of his devotion and respect for the art, he goaded the family into donating his father's and grandfather's (Stephen M. Parrish – etcher and landscape artist) papers, photographs, memorabilia and studies to the Dartmouth College Baker Library – Special Collections section, where they reside today. Consequently, the Parrish Family Collection is a resource for scholars into the next millennium. Without that cache as a source, we would have little to go on in researching the man and his art, and so we hereby acknowledge Maxfield Parrish Jr. for his foresight and endeavors at preserving his father's legacy. Max Parrish Jr. and Coy Ludwig's efforts are what first prompted our research and they continue to inspire our on-going studies into Maxfield Parrish's oeuvre.

We would also like to acknowledge the many diehard fans and aficionados of Maxfield Parrish, for during the period when there was a dearth of books and accurate information, these art-lovers subsisted solely on vintage prints.

Finally, we thank Alan Rothschild and Alex Mendoza, two men with clear purpose, positive direction and unbridled enthusiasm for the art of Maxfield Parrish, for their continuing efforts on behalf of this great artist.

Judy and Laurence Cutler
National Museum of American Illustration
Vernon Court,
Newport, Rhode Island, U.S.A.
Spring 1999

PLATE 1
Jell-O Ad (1921)
Vintage print
Genesee Pure Food Company

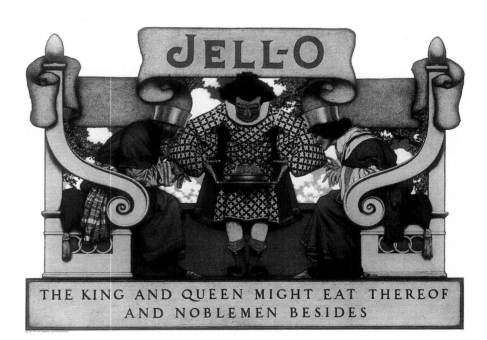

PLATE 2

The Knave of Hearts: The King Samples the Tarts (1924)

Oil on paper laid down on panel, 19¼ x 15¾ inches
(48.9 x 40cm)

The Knave of Hearts by Louise Saunders, Charles Scribner's
Sons, NY

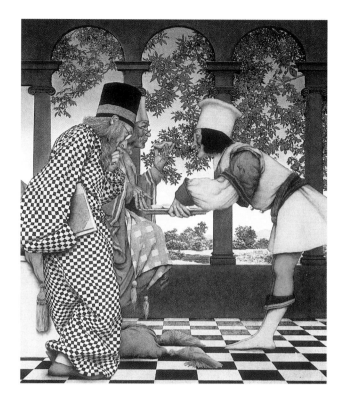

A PREFATORY NOTE

This book is designed so that practically anybody can afford
a copy; its illustrative content is brilliantly handsome and
the text is both concise and compelling. I hope that the
reader finds it true to form, as I did. But what is truly
remarkable is that, for the most part, the illustrations
contained herein are images which have either been lost or
were up to the present unheralded by connoisseurs.

Many of these images were unknown to collectors and
are therefore considered 'fresh' to both the serious Parrish
groupies and to the public's eye. Some esoteric, vintage art-
print collectors will undoubtedly say that they have seen
some of the images contained herein. The likelihood is that
they probably have not, or if so, that they were seen only
for a fleeting moment in a museum or perhaps at the
American Illustrators Gallery in New York, where I viewed
my first Parrish originals. Otherwise, these images have
been rarely displayed, photographed, exhibited, or
republished since their creation. Having said that, Maxfield
Parrish's most famous images are already very well known
to the world. They proliferate on calendars, and have hung
on countless walls as art prints for over 75 years. The
authors have done the reader justice by also adding a few of
those better known images to assuage initiates to the world
of Maxfield Parrish, since they always seem to expect to see
the great classics.

Parrish's popularity was at its zenith in the 1920s and
30s; it waned, rose, died down, and now it is steadily on the
rise again. Perhaps this is an odd comparison to make, but
contemporary artist David Hockney has had over 250 solo
art exhibitions and is still actively painting at 60 years of
age, while Maxfield Parrish, in his 128th birthday
anniversary year has had altogether a mere 25 exhibitions.
Yet there are precious few persons who will recognize a
Hockney work and Maxfield Parrish's art works are world
renowned.

The popularity of this American illustrator at the
beginning and at the close of this century is unparalleled.
His images are now coveted in 42 countries. There are
whole shops specializing in derivative art products with
Parrish's lush landscapes and delicate 'girls on rocks.' Like
other great artists throughout the centuries, Parrish's art and
popularity will endure since it has proven itself to be
timeless. I now invite this art-appreciating audience, you
the reader, to delve into his work with a new opportunity
to view this unique artist's undertakings.

I know that you cannot help but enjoy that which you
will find herein, just as I have.

Philippe Paul Cézanne

Paris

Spring, 1999

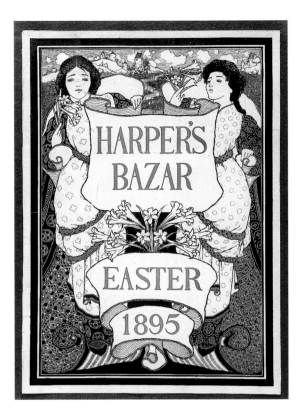

A FAMILY OF NOTE

The family of Maxfield Parrish is as blueblood as one gets in America. Its lineage can be traced back to the very earliest settlement in Maryland, the Maryland Colony. The first family member in America was Captain Edward Parrish (1605–1679). According to family history, he was born in Yorkshire, England in 1605 and emigrated to Ann Arundel County, Maryland in 1637, a year after Harvard College was founded. Subsequent family history shows continual prosperity for generations of Parrish kin. The family is profligate with persons of great integrity: many were recognized by their communities for lofty professional accomplishments, but they were uniformly all conservative and plain folk until the arrival of Stephen M. Parrish (1846–1938) and his son Maxfield Parrish (1870–1966).

The Parrish family lived comfortably in Maryland until suddenly moving en masse to Pennsylvania – the Quaker State. The reason for this major upheaval and relocation has long since evaporated. The first mention of a Pennsylvania link to the family is in church records. Robert Parrish, the son of John Parrish of Baltimore County, MD, joined the Philadelphia Meeting of the Society of Friends, commonly called the Quakers, in 1750. It is from that point forward that the family ascribed its origins to Pennsylvania, rather than Maryland.

One hundred and seventy-five years later, Susanna Parrish Wharton compiled a book entitled *The Parrish*

Family (Philadelphia, Pennsylvania), documenting her family's American quest. An earlier version of this tome had been assembled and written by Dillwyn Parrish (1809–1886). Susanna's version, written in 1925, made special references to her grandfather Joseph Parrish, MD (1779–1840), the great-grandfather of Maxfield Parrish. Joseph Parrish was immortalized in a marble bust created by Louis Saint-Gaudens, brother of the noted sculptor, Augustus Saint-Gaudens. Susanna's genealogical work brought the family records up to date and contained original anecdotes including several from the Revolutionary War days. Incredibly well peppered with lively verbal sketches, the book is embellished with stories of relationships with Indians and joint escapades in the earliest days of the colony. Obviously the book was compiled for family use, but the current fame of Maxfield Parrish brings one to scrutinize it in order to learn more about his origins and genetic precedents. Another benefit to reading this family document is to gain insights into the Philadelphia society in which Maxfield Parrish was raised in the 1870s and 80s.

THE BOY, 'FRED' PARRISH

Frederick Maxfield Parrish was born to Stephen M. and Elizabeth Bancroft Parrish. At the time of his birth, his father was 24 years old and had the sole ambition in life to become a famous artist and oddly, his family was sympathetic to this professed goal. However, it should be

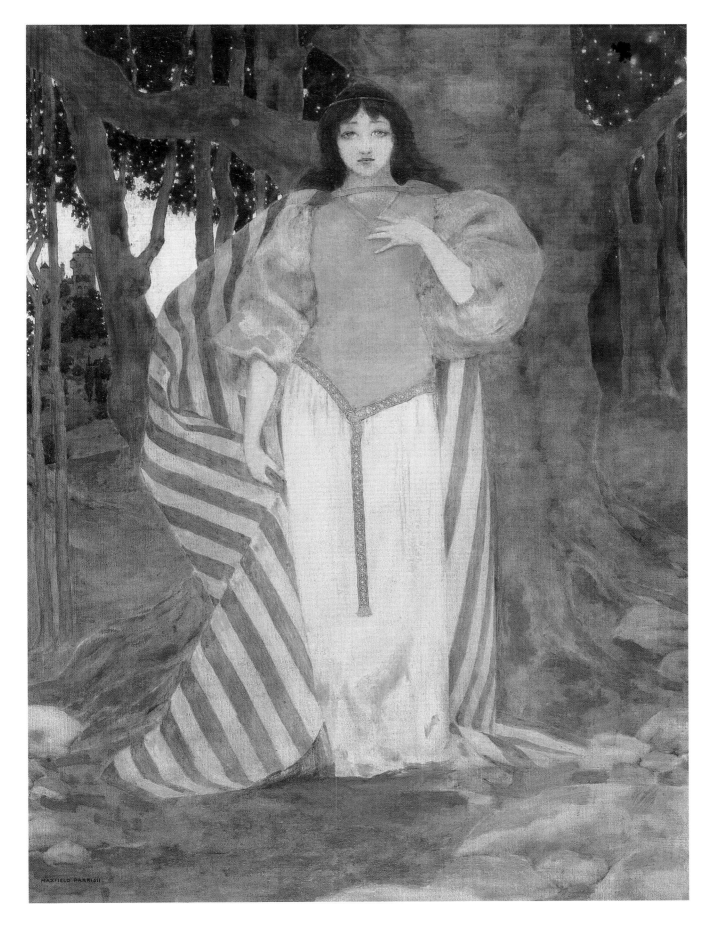

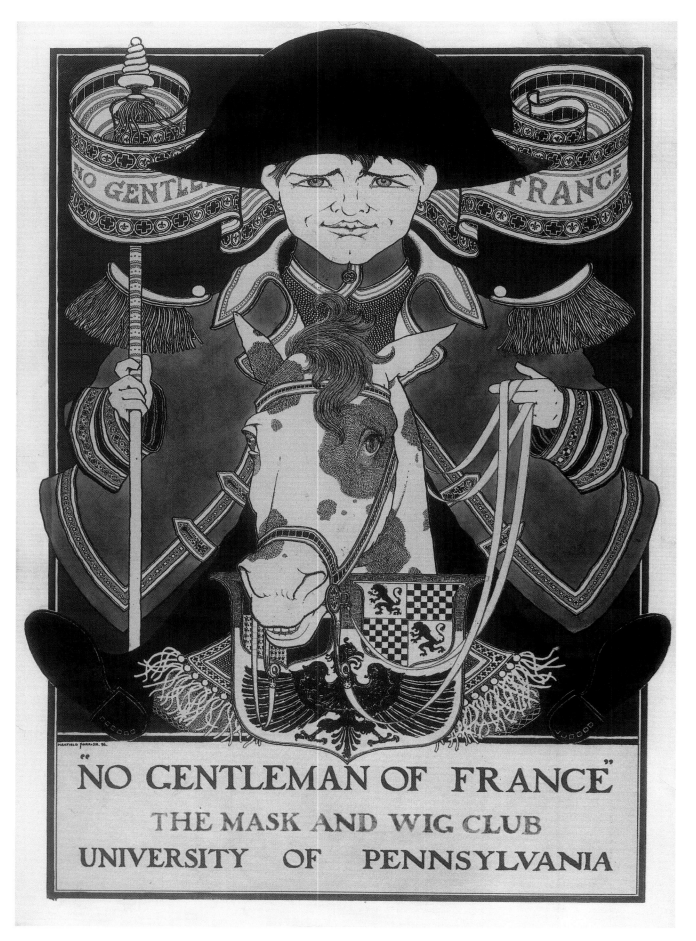

"NO GENTLEMAN OF FRANCE"
THE MASK AND WIG CLUB
UNIVERSITY OF PENNSYLVANIA

PLATE 5 opposite

No Gentleman of France (1896)

Oil, pen and black ink on paper, 19¹/₂ x 13¹/₂ inches
(49.5 x 34.3cm)

Design for the Mask and Wig Club drama poster

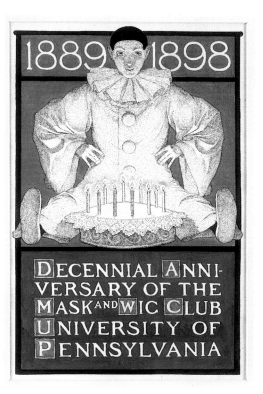

PLATE 6 right

Decennial Anniversary Cover (c.1898)

Watercolor and ink on paper, 15³/₈ x 11¹/₂ inches
(39 x 29.2cm)

Design for the decennial anniversary of the Mask and Wig
Club, University of Pennsylvania

pointed out that this was quite unusual for a Quaker family
such as the Parrish clan to tolerate, being deeply immersed
in the principles of proper Quaker life. An artist could
hardly fit in. In fact, such an ambition was not even on the
menu for future undertakings within their society.
Decoration, painted images, sculpture and any
embellishments at all were considered unnecessary to
pragmatic use and were frowned upon by all. And the
Parrish family was no different than any other Quakers of
the times. Artists were disparaged in this context where
simplicity was the only choice open to young people. The
allowable professions did not include the 'frivolous pursuit
of the arts.' But the Parrish family was apparently more
worldly than the others, perhaps more loving of their child's
inner drives and needs, and they supported this endeavor.
Until Stephen began longing to be an artist, the traditional
family occupations were those of the professions: physicians
and lawyers, but also bankers and men of property – the
'upper class occupations.' In spite of their caring and
understanding, it is not difficult to imagine the initial horror
within the family when they discovered an artist was
actually living amongst them.

To complete the picture of the rebel within, Stephen
Parrish decided that his name was just 'too plain,' and
confiscated his mother's maiden name (Susanna Maxfield,
wife of Dillwyn), to give himself a middle initial which he
lacked from birth. Needless to say, it was extraordinarily

eccentric for a Quaker boy to 'name himself,' so to speak.
Yet Stephen felt that he could add more melodic rhythm by
adding an initial to his name, and felt that it gave him a
distinct *panache* in an otherwise bland environment.
Likewise, his son Fred, who throughout his life followed in
his father's every footstep, took the entire maiden name of
his maternal grandmother to become **Maxfield** Parrish, his
nom de plume. Fred Parrish became known not only as
'Maxfield Parrish', but as 'MP' to his millions of fans. His
birth name 'Frederick,' or 'Fred' and that initial 'F'
disappeared altogether except within the family circle. The
last time he used 'Fred' or 'F,' as a signature was when he
was 24 years old, hauntingly identical to his dad's timing
and name change. Maxfield Parrish did not use a middle or
first initial since the name 'Maxfield' itself provided the
melodic content he sought.

Parrish family heritage and accomplishments continued
to be important to MP after marrying a Hicksite Quaker
girl, Lydia Ambler Austin from nearby Woodstown, New
Jersey. The Hicksite Quakers were named for the Hicks
family which comprised the nucleus and better part of a
New Jersey splinter sect originating amongst the
Pennsylvanian Quakers. One of the Hicks clan, Edward
Hicks was a very well known primitive artist, perhaps best
known for his painting entitled the *Peaceable Kingdom* (circa
1830). The Hicks family dominated the Southern Jersey
Meeting and consequently they were soon referred to as

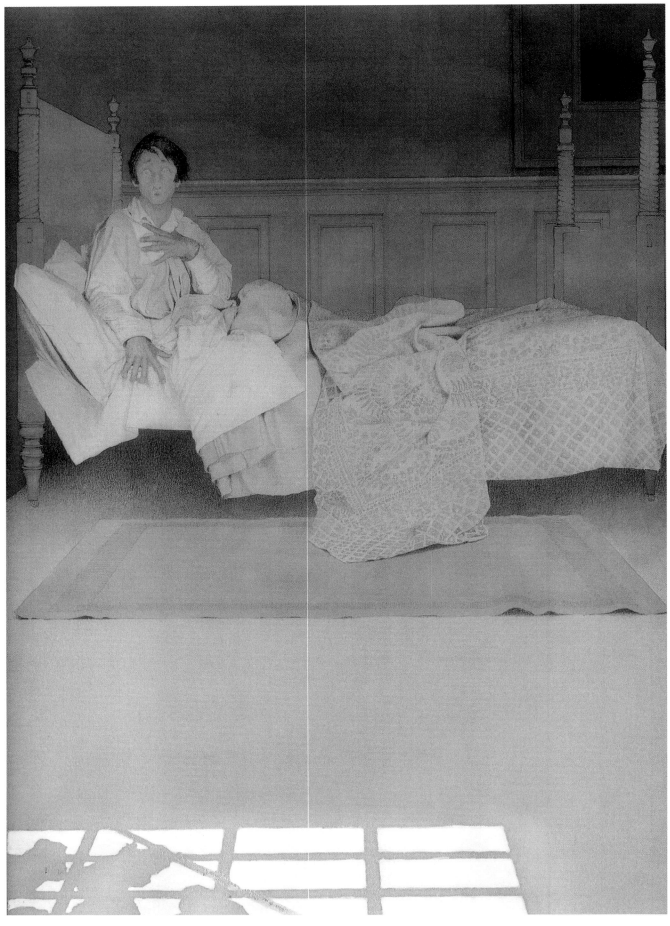

PLATE 7 opposite
The Blue Room (c.1899)
Pencil and gouache on paper, 13 x 9 inches (33 x 22.9cm)
The Golden Age by Kenneth Grahame, John Lane: The
Bodley Head

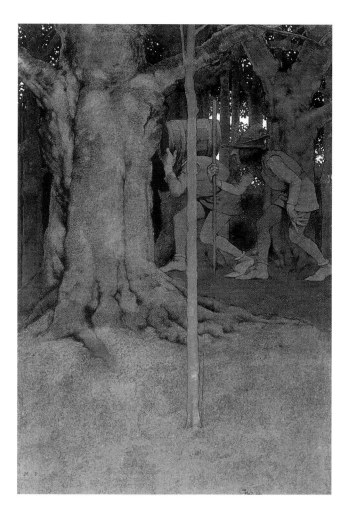

PLATE 8 right
The Olympians (1899)
Watercolor, oil and black ink on paper, 11 x 7 inches
(27.9 x 17.8cm)
Title page for *The Golden Age* by Kenneth Grahame,
John Lane: The Bodley Head

'Hicksites.' Although their practices were nearly identical religiously, the Hicksites incurred the wrath of other nearby Meetings. Consequently, MP was resoundingly castigated by his family's own 'free ministry of the Gospel' for marrying into the Hicksite sect. Over the years, perhaps as a consequence of such irrational prejudices, he transformed into a decided agnostic and never believed in God, but rather in Nature as the life force. Nevertheless, Maxfield Parrish espoused Quaker philosophies of non-violence and charity to his dying day. He had well learned the virtues of service and humanitarianism as a youth at home and in Quaker schools at both Swarthmore and Haverford.

Maxfield Parrish successfully convinced his wife Lydia to name their children after *his* family members rather than Austin Hicksites. Not so oddly for the times, Lydia graciously went along although it was his sect which did not accept her own. As the dutiful wife, their children's names honored his family heritage: for their first child MP selected *Dillwyn*, for his great-grandfather; *Maxfield, Jr.* – to make no mistake about a mellifluous name for the number two son; and the third was named *Stephen* for MP's father. The only daughter Jean, born in 1911, was apparently not named for

anyone in particular as family records do not show another 'Jean,' either before or since. Interestingly, Maxfield Parrish's great-granddaughter is named 'Amber,' a variation of 'Ambler,' taking her grandmother's maiden name directly from the Hicksite side – times have changed.

LIKE FATHER, LIKE SON
The significance of Maxfield Parrish copying his father's lead over and over again began in a small way with his name, but continued in many other more important respects for the rest of his life. It is certainly an interesting psychological study to trace similarities between artist father and artist son. The son consistently emulated the father, both in his career and in life choices and actions; we mention here but a few for consideration:
- Both men diverted from secure and prosperous career tracks offered to them by their family for the challenging and risky lives of artists. Such artists' lives were antithetical to their upbringing, to their religious training and Quaker lifestyles;
- Both men began painting at very young ages. Stephen was self-taught while Maxfield had the advantage of

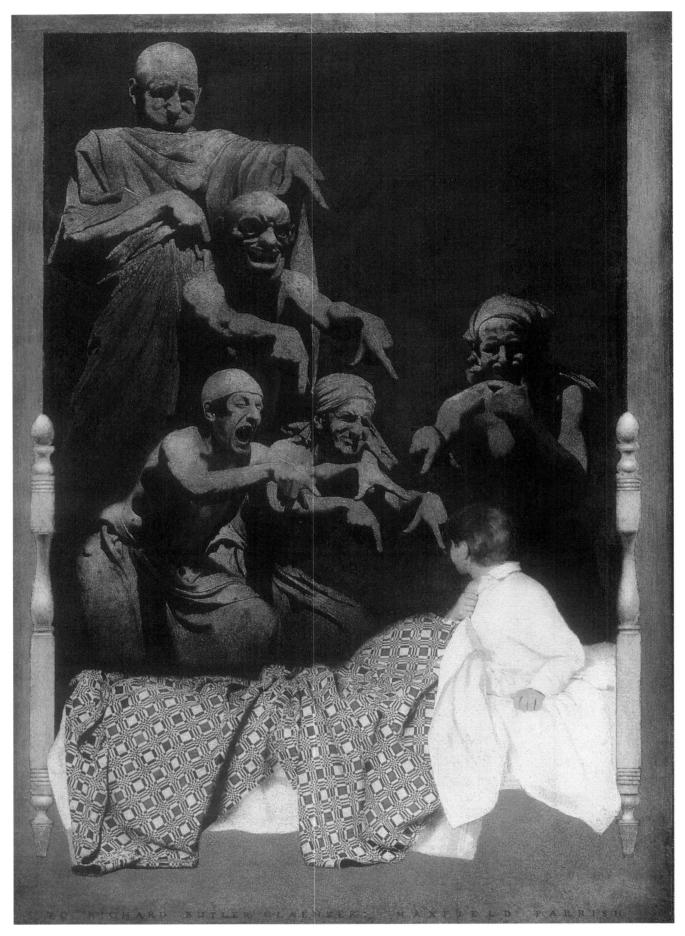

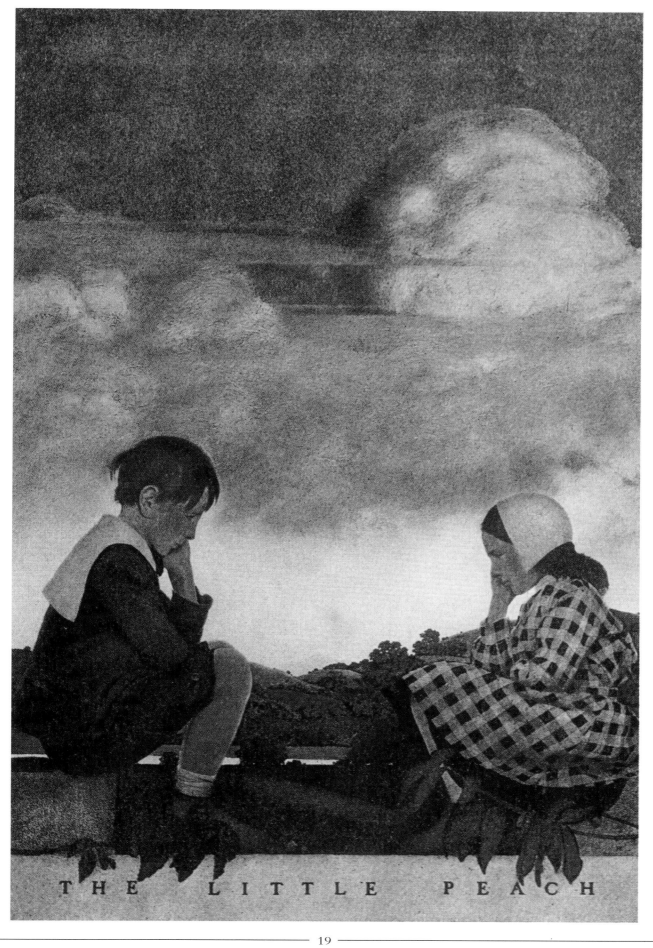

THE LITTLE PEACH

PLATE 9 (Page 18)

Seein' Things at Night (1904)

Oil on panel, 21¹/₄ x 14³/₄ inches (54 x 37.5cm)

Poems of Childhood by Eugene Field, Charles Scribner's Sons, NY. Published in *Ladies' Home Journal*

PLATE 10 (Page 19)

The Little Peach (1904)

Oil on stretched paper, 21¹/₄ x 14³/₄ inches (54 x 37.5cm)

Poems of Childhood by Eugene Field, Charles Scribner's Sons, NY, 1904. Originally published in *Ladies' Home Journal*, March, 1903

PLATE 11 below

Comic Mask (1905)

Sculpture, bronze casting, 7 x 5 inches (17.8 x 12.7cm)

PLATE 12 opposite

The Fly-Away Horse (1904)

Oil on stretched canvas, 28¹/₄ x 20¹/₂ inches (71.8 x 52cm)

Poems of Childhood by Eugene Field

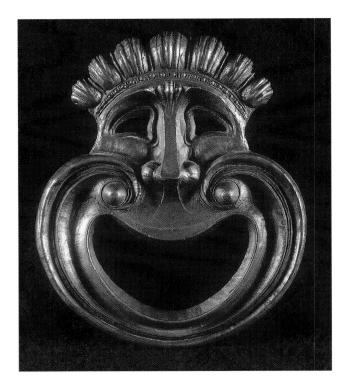

his father as personal instructor. Stephen was not only an accomplished easel artist, but he was recognized as one of the three greatest etchers in the world at one time. The father-son art lessons began when MP was but six-years-old;

- Both men enjoyed travelling, especially in Europe and did so frequently throughout their lives;

- MP following his father's lead, built a home in New Hampshire in the same artist colony at Cornish;

- Both men delighted in the Cornish Colony and its coterie of talented artists, writers and intellectuals. Interestingly, in spite of age differences, both father and son were close personal friends of Augustus Saint-Gaudens, the noted sculptor and charismatic leader around whom the art colony had formed. In fact, they shared many close friends, age differences apparently meaning nothing;

- Both men built separate studios on their estates to work without the bother of family, friends or staff;

- Stephen was internationally known for his etching, but near the end of the 19th century he turned exclusively to landscape painting, having won the acclaim of the world for etchings. Likewise, after gleaning worldwide plaudits for illustrations, MP turned exclusively to landscape painting in his twilight years. Both men lived well into their nineties;

- Stephen's wife Elizabeth left him for a California commune and never returned – an unusual occurrence in Victorian America. Maxfield Parrish adored his father and was devastated when his parents split up. At that time, MP was in the process of moving to New Hampshire to be near his beloved parents. He never recovered from the shock to his small family. Perhaps from that moment onwards he became more abstracted from Lydia and, like his father, focused primarily on art. Lydia never totally left MP, but she separated from him annually for months on end. Each winter she traveled to the Georgia Sea Islands where she died alone in 1953. During decades of winters apart, MP lived in his studio with his companion, Susan Lewin.

- Stephen felt that MP needed more help at The Oaks in order to spend his time more effectively on art rather than 'family chores.' Stephen had an assistant, Marguerite Lewin, who suggested her niece Susan Lewin to assist MP at his estate, 'while she assisted his dad at Northcote.' Susan Lewin came to the Maxfield Parrish family originally as an au pair, but within weeks

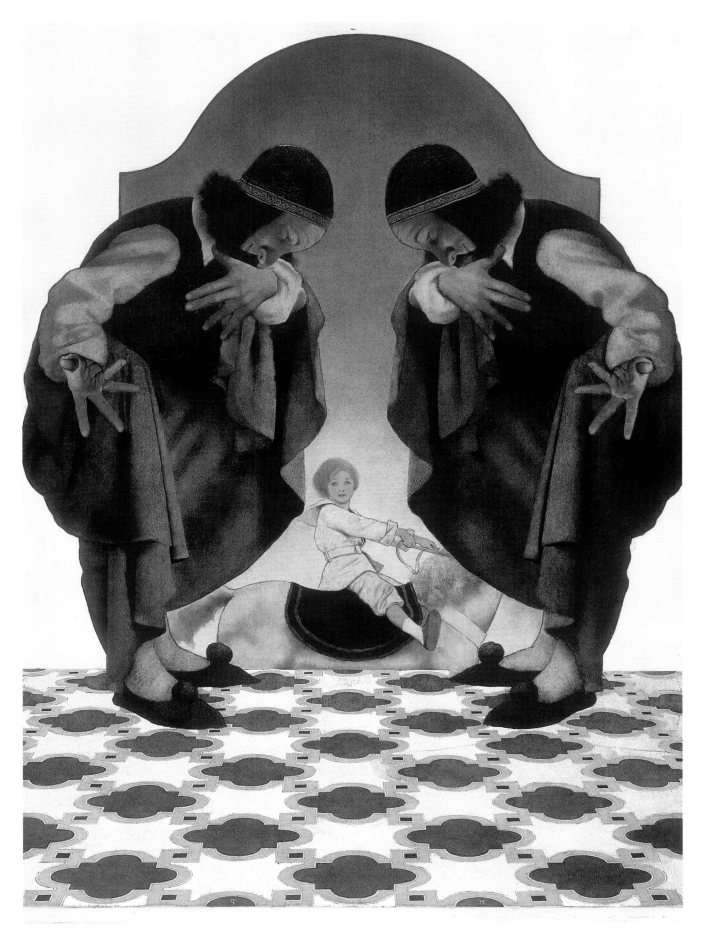

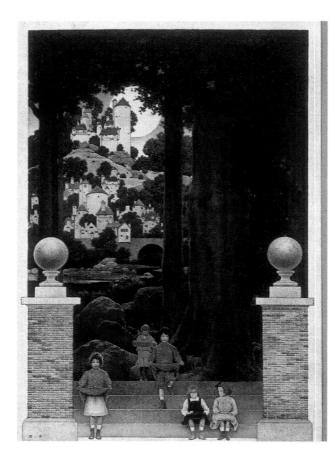

PLATE 13 left
The Sugar-Plum Tree (1905)
Vintage print
Poems of Childhood by Eugene Field, Charles Scribner's Sons,
1904

PLATE 14
The Tramp's Dinner 1905
Oil, 28 x 18 inches (71.1 x 45.7cm)
Collier's The National Weekly, Thanksgiving number,
18 November 1905. (Courtesy Delaware Museum of Art)

she became MP's studio housekeeper and model, and later his companion – a relationship which lasted over 55 years.

Such similarities are astoundingly parallel and more Freudian than coincidental.

EUROPEAN PRECEDENTS AND STEPHEN PARRISH

Stephen Parrish doted on his only child and first noticed inklings of talent in the light-hearted parodies and caricatures drawn by the boy to entertain classmates at school. Wishing to harness this pent-up talent, Stephen exposed his son to the world of fine art and traveled with him to museums throughout Europe, visiting the greatest private art collections en route. Maxfield Parrish became imbued with art works by the greatest of the Old Masters and Renaissance artists. He visited the Louvre at the age of seven, again at fourteen, and then intermittently throughout his life. He particularly loved pre-Raphaelite art, especially that of Dante Gabriel Rossetti and Frederick, Lord Leighton. After returning from Europe to preparatory school at Swarthmore, Parrish's interest was ignited by the art he had seen in Europe. This fire developed into a burning passion.

In 1888, Maxfield Parrish entered Haverford College with a major in architectural studies – the only subject which interested him other than fine art. Architecture, considered 'the Mother art', was a noble endeavor indeed, but too disciplined for the creative soul burning inside the young artist. At Haverford, cartoons from his Swarthmore days were displayed in the dormitories and with them came requests to undertake book-cover designs, event programs, concert posters and the like. After three years of Haverford's architectural drafting courses, during which he was obliged to draw Corinthian column capitals ad nauseam, he could no longer stand the inane, repetitive Beaux Arts classical exercises and 'dropped out', perhaps one of the first 'dropouts' in history as no one went against the norm in those days. MP simply left school. In fact, in most families he would be considered a 'quitter!' Getting his father's blessings, Parrish immediately entered the Pennsylvania Academy of the Fine Arts (PAFA) in nearby Philadelphia, to formally study painting and to become a professional artist. It was during this period that his first few sketches and paintings were still signed 'F. Maxfield Parrish.'

Soon he realized his incredible talent and technical skills were greater than his classmates. Faculty quickly recognized his technical prowess and the young, unusual artist with such unique imagery, began to glean commissions. Along with the commissions and recognition came ego,

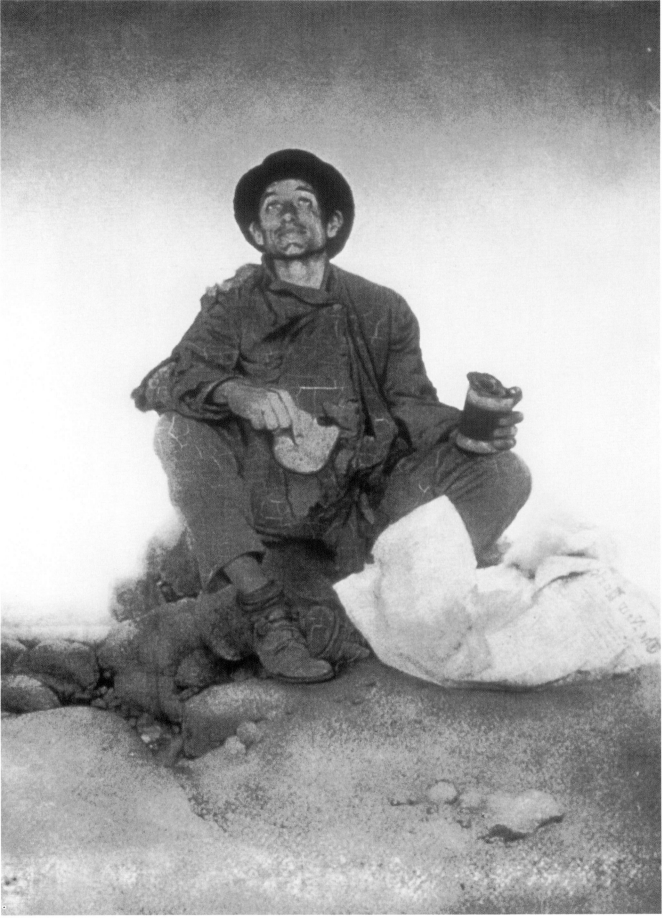

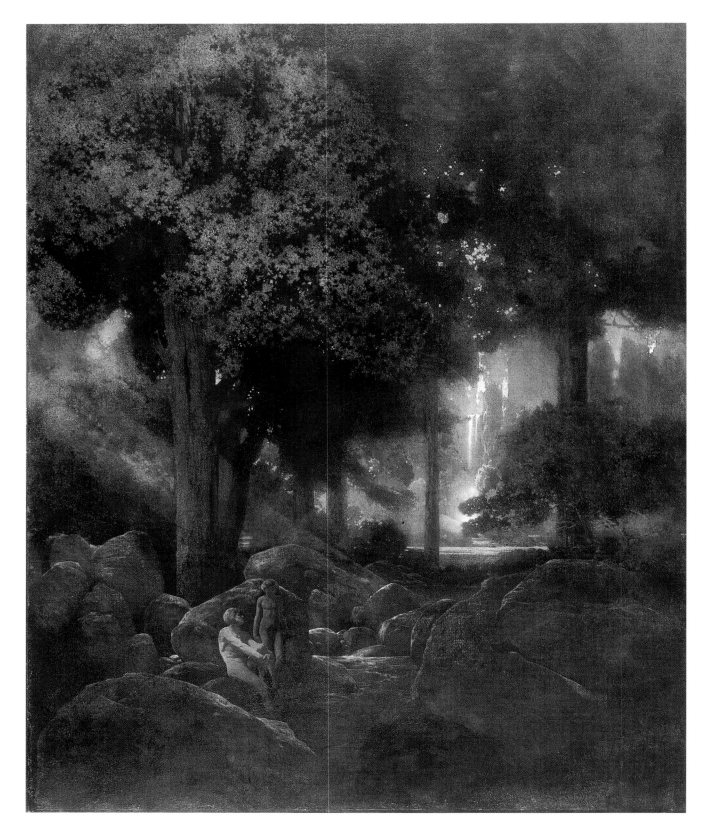

PLATE 15

Fountain of Pirene (1907)

Oil on canvas mounted to wood panel, 40¼ x 32 inches

(102.2 x 81.3cm)

A Wonder Book of Tanglewood Tales by Nathaniel Hawthorne

PLATE 16 left

The Last Rose of Summer (c.1906)

Drawing in black-and-white with color added by publisher.

The Outing Magazine cover, November 1906

PLATE 17 below left

Collier's **Magazine Cover – Study** (1908)

Oil with graphite on board, 22 x 16 inches (55.9 x 40.6cm)

Collier's magazine cover study for June 1908

particularly the ego of the name 'Maxfield Parrish,' for that name rose to the surface for evermore.

'Maxfield Parrish, the artist,' was born at the age of 24. He never signed anything with 'F' or 'Fred' again, for he was now and forever more *Maxfield Parrish, the artist*.

THE MILESTONE YEARS

Fully committed to an art career, MP spent more and more time with his father at the summer artist colony, Annisquam, near Gloucester, Massachusetts. While father and son grew closer during this period, his mother grew more distant from both father and son. Yet these were the milestone years for his career:

- **1894** – First commission to paint a mural for the Mask and Wig Club of the University of Pennsylvania. (This work was unceremoniously auctioned in New York in 1996, to raise monies for the Club);
- **1895** – Audits classes with Howard Pyle, the 'Father of American Illustration' at Drexel Institute in Philadelphia and marries Lydia Austin;
- **1896** – Executes a prize-winning poster for the Pennsylvania Academy, thus establishing his reputation as an illustrator. The PAFA poster becomes the most

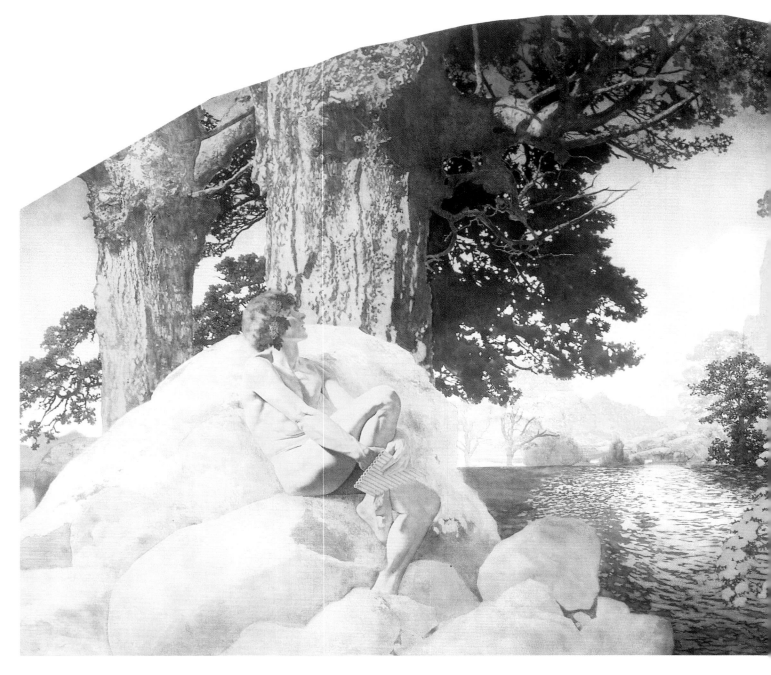

reproduced poster of the decade!

Wins commissions from *Century*, regarded as America's most prestigious magazine publication;

- **1897** – Elected to the Society of American Artists at 27 years of age;

- **1898** – Designs and builds 'The Oaks' at Plainfield, New Hampshire, mimicking his father, who had built an estate, 'Northcote', just across the valley in Cornish, in the midst of the art colony. In the same year, in a rather uncharacteristic move for the times, Elizabeth separated from Stephen and moved to California to join a religious commune. Interestingly, this occurred in 1898, shortly after MP had experienced several

important personal and career milestones which, at a very early age, surpassed his father at the zenith of his popularity. The year 1898 was arguably the major milestone year in the life of Maxfield Parrish. It heralded a host of business connections and illustration commissions, each one emanating from the preceding one. Magazine covers, books and stories were embellished with reproductions of his lavish paintings and depictions, theatrical set designs enhanced the dramatic performances, and then Parrish's original art works went on exhibition. He had become a national star. His art graced the covers of magazines on every news-stand. MP had recently joined the Players Club, a meeting place of other stars

PLATE 18
Dream Castle in the Sky (1908)
Mural, oil on canvas, 6ft x 10ft 11inches (182.9 x 332.7cm)
(Courtesy Minneapolis Institute of Arts)

A POWER LEGION

Frequently one uses or hears the phrase 'it's a small world' yet with exponential world population growth and less time available, it is astounding that one can still make that statement. John Guare authored an interesting book entitled *Six Degrees of Separation*, based on a true story reported in the *Boston Globe*. The book was later adapted into a Broadway show and then into a feature film. Its premise was based upon a young African-American who used contacts and name-dropping to gain access to a Fifth Avenue apartment in order to defraud the sophisticated family of an MIT graduate. The young black man befriended a family member, then stole his address book and so the story goes. With each step the young thief name-drops his way to the next individual in a daisy chain of phony links. Of course, the thesis is that any person today has personal contacts with enough people to get to anyone else in the world, but six is the longest linkage required. Presumably, this means that Elton John would have accessibility to an Australian aborigine through mutual friends or acquaintances – although not likely.

Yet, it amazes one to review the relationships, interrelationships and linkages of the persons surrounding Maxfield Parrish from The Players. The overlaps in contacts and tangential links between them were truly only *six degrees of separation*, and perhaps fewer. The Players Club was *the* social place and membership assured success if one

and star-makers – the proverbial 'movers and shakers.' As a direct result of The Players, his career was forever assured due to the contacts he made there.

It is more interesting to describe the influence of The Players on Parrish and his notable peers. It was, in a word, of *paramount* influence on his development – he blossomed into 'a businessman with a brush.' This facet of his life has never been truly explored, but we describe the plethora of relationships and interrelationships at The Players in Gramercy Park as a testimony to its significance on his career and others.

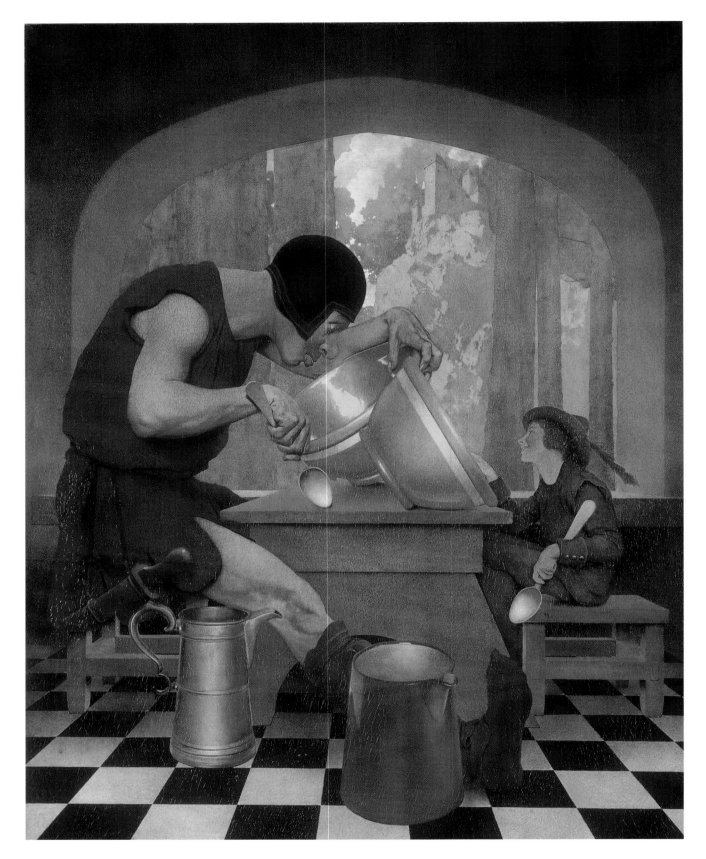

PLATE 19 opposite
Jack the Giant Killer (1909)
Oil on panel, 30 x 24 inches (76.2 x 61cm)
Hearst's Magazine, June 1912

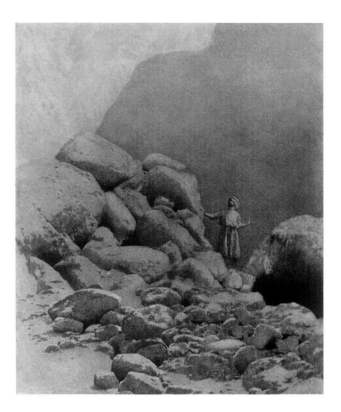

PLATE 20 right
The Second Voyage of Sinbad (1909)
Vintage print.
The Arabian Nights: Their Best Known Tales, edited by Kate Douglas Wiggin and Nora E. Smith, Charles Scribner's Sons, NY

had the proper professional credentials to provide potential client-users with what they required. Many of them as publishers, journalists, writers and art directors, required illustrators.

THE PLAYERS CLUB – FOUNTAINHEAD OF CULTURE

The world at the beginning of the 20th century was indeed a small place. Few persons excelled in the arts without proper education and the requisite social contacts. Those who had talents and contacts often banded together, self-sequestered in colonies at Provincetown, in Cornish, in lofts in Greenwich Village, or living as expatriates on the Left Bank, in Paris. Within each circumspect Lilliputian world, artists participated in intellectual camaraderie; they thrived as Bohemians and endeavored in their respective crafts. Sometimes they formed movements, sometimes they were pigeon-holed into groups ('The Ten'/'The Luminists') or they simply relaxed at elitist retreats peopled with patrons, and bon vivants. The complementary nature of the arts tended to couple writers and poets, painters and sculptors, architects and landscape designers, all souped together socially and geographically. Alongside the creatives were publishers and editors, critics, connoisseurs and collectors, and they flourished symbiotically, both host and parasite. The most fertile ground for such was unquestionably in Gramercy Park at The Players Club. The Players was a meeting place for rising young artistic talents, business men

and others who enjoyed being referred to simply as 'POAs,' or 'Patron of the Arts.'

In the late 19th and early 20th centuries, almost everything circled around one's social life in New York, summers in Cornish or on Bellevue Avenue in Newport. But The Player's Club was unquestionably the cultural epitome, the *actual fountainhead of culture*. Founded in 1888 by the admired Shakespearean actor Edwin Booth (brother of despised assassin John Wilkes Booth), the Club was the American counterpart to London's legendary thespian gathering place, the Garrick Club. The founding notion was that the theater world would be enhanced by contact with the other arts and would thus broaden the intellectual horizons of its members. Architect Stanford White, a founding member, gladly renovated the building which Booth purchased for the purpose of establishing a clubhouse in Gramercy Park.

The specific members of The Players with whom Maxfield Parrish associated overlapped with each other as their intellectual territories superimposed and other interests commingled geographically. Their circles of influence were avant-garde and comprised the greatest creative spirits extant.

THE POWER LEGION AND THE CORNISH COLONY

It is uncanny to review the interpersonal relationships which molded those few, select personalities (a group which Edith

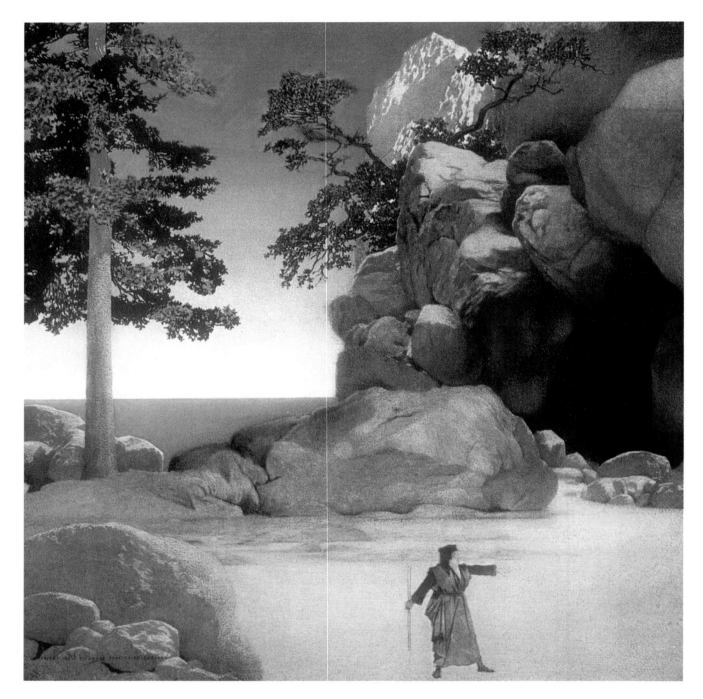

Wharton referred to as 'The Happy Few'), who in turn molded American society with their cultural contributions. To identify their affiliations, we have placed the letters (P) for The Players Club members, (CC) for Cornish Colony residents, and (NA) for members of the National Academy of Design after the respective surnames. Many of this group had multiple designations being residents of Cornish, members of The Players as well as those honored with admission to the National Academy. They all knew Parrish: they were his friends, admirers and fans and in many instances his clients.

Let us therefore play The Players game: Stephen Parrish

(CC), father of Maxfield Parrish (P/CC/NA) settled in Cornish in 1893, as a result of his friendships with both the Irish-born Augustus Saint-Gaudens (P/CC/NA) and architect Charles Adams Platt (P/CC/NA). Platt's garden designs greatly influenced the Philadelphia architect Wilson Eyre, Jr., whom he introduced to Stephen M. Parrish. Eyre was hired by the older Parrish to design his Cornish home, Northcote.

Sculptor Augustus Saint-Gaudens first visited New Hampshire in 1885, invited by New York City attorney Charles Cotesworth Beaman (P/CC). Both Beaman and Saint-Gaudens were founding members of The Players Club

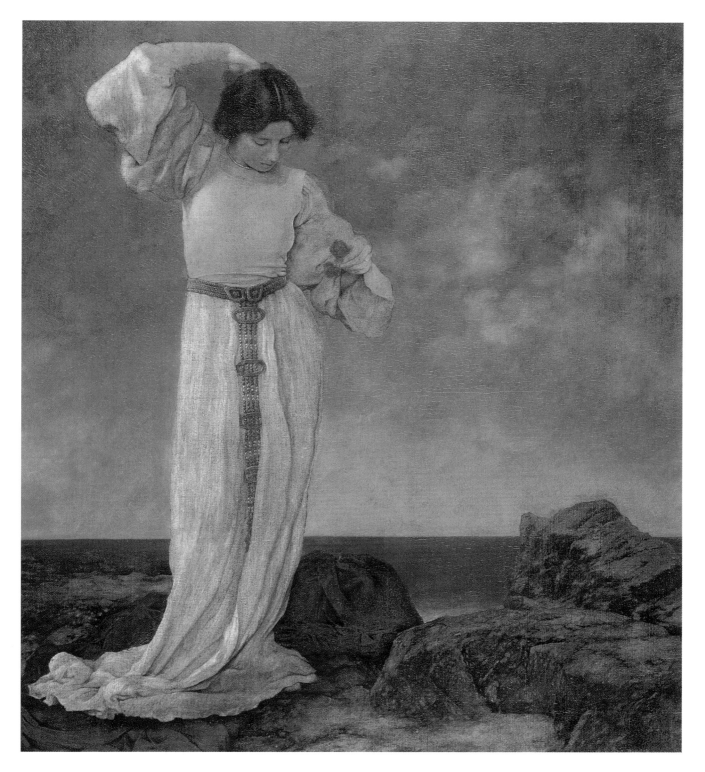

PLATE 21 opposite
The Tempest: **Prospero in Golden Sands**
(1909)
Vintage print, 7 x 7 inches (17.8 x 17.8cm)
Art print published by Dodge Publishing Co., originally
painted for Winthrop Ame's and Hamilton Bell's production
of *The Tempest* by William Shakespeare, staged at The New
Theatre in New York City in 1909.

PLATE 22 above
Griselda (Seven Green Pools at Cintra)
(1910)
Oil on canvas mounted on a wood panel,
40 x 32 inches (101.6 x 81.3cm)
Century magazine, August, 1910

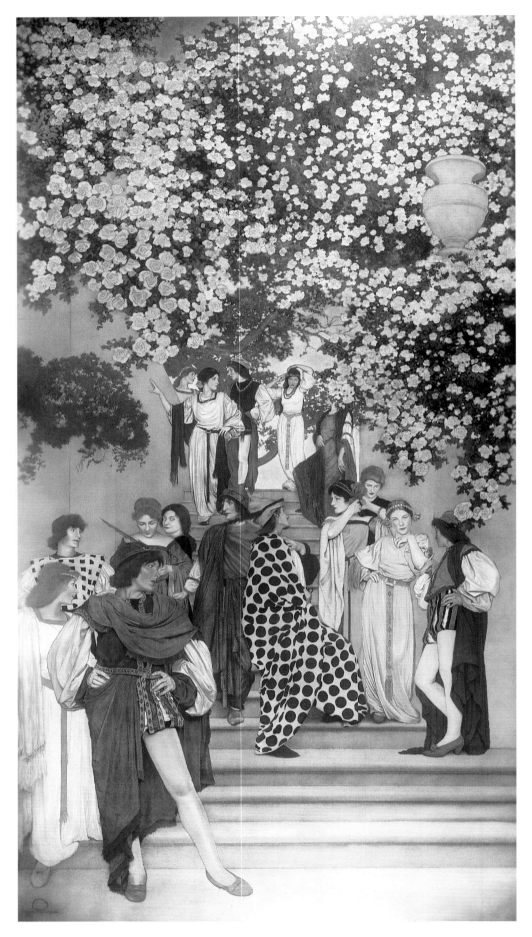

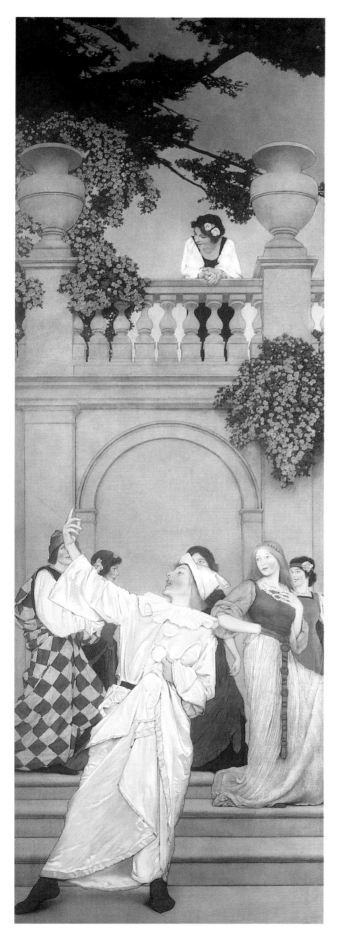

PLATE 23 opposite

A Florentine Fete: Buds Below the Roses
(1912)

Oil on canvas, 126 x 65 inches (320 x 165cm)

Mural for girls' dining room, Curtis Publishing Company, Philadelphia. (Courtesy The National Museum of American Illustration, Newport, Rhode Island)

PLATE 24 left

A Florentine Fete: A Call to Joy (1911)

Oil on canvas, 126 x 39 inches (320 x 99cm)

Mural for girls' dining room, Curtis Publishing Company, Philadelphia. (Courtesy The National Museum of American Illustration, Newport, Rhode Island)

(1888) and the Cornish Colony (1885). The National Arts Club (1898) was founded essentially by the same 'Happy Few,' including Saint-Gaudens, Stanford White, Henry Clay Frick and Charles de Kay, to mention a few of The Players involved next door at Gramercy Park. These prime movers all easily blended into the convivial atmosphere of artists and businessmen and they attracted others of like talent and mind to the new club. It offered its members the same atmosphere Beaman attempted to create at his New Hampshire summer colony. Infected with a love of the rustic, Beaman bought a slew of New Hampshire farms to develop a colony exclusively for New Yorkers of similar goals. Envisioning a unique refuge from the noise and filth of city life, he went to great lengths to ensure that it would not resemble the tediously boring Long Island resorts; but it could aspire to be a more casual retreat for a *select few*.

The Parrish family connection to the Saint-Gaudens clan was originally through Stephen's uncle, Samuel L. Parrish (P), who had commissioned Louis Saint-Gaudens (CC), Augustus' brother and assistant, to sculpt a bust of his father Dr. Joseph Parrish (great-grandfather of Maxfield Parrish). Like Beaman's invitation to Saint-Gaudens, it was Saint-Gaudens' invitation to Stephen M. Parrish to spend a week in the country which persuaded him to uproot and move from Philadelphia.

Wilson Eyre, Jr., AIA, designed a mansion and stable for Charles Lang Freer (P) in Detroit. A noted society

PLATE 25

A Florentine Fete: The Garden of Opportunity (1913)

Oil on canvas, 126 x 54 inches (320 x 137cm)

Mural for girls' dining room. Curtis Publishing Company, Philadelphia. (Courtesy The National Museum of American Illustration, Newport, Rhode Island)

architect, Eyre was born in Florence, Italy to a Philadelphia family and had just completed the design for Northcote, in 1893, when commissioned by the University of Pennsylvania to renovate a stable for its drama club. A year later, Eyre reciprocated that commission by suggesting that Stephen's son be hired to paint the decorations for the club. Young Maxfield 'Fred' Parrish, already an honorary member of the Mask and Wig Club (see plates 5 and 6 from the Mask and Wig programs), painted his first commissioned work, the mural entitled *Old King Cole* which regally hung above the club bar from 1895 for a hundred years.

Charles A. Platt (P/CC/NA) designed a house in Cornish in 1888 for the artist Henry Oliver Walker (P/CC/NA), at the suggestion of Augustus Saint-Gaudens. Barry Faulkner (P/CC/NA), a Parrish family friend, created the murals for the American Academy in Rome. Maxfield Parrish availed himself of both Faulkner's and Platt's intimate knowledge of Italy when it came time for him to journey for the book authored by Wharton and illustrated by MP, *Italian Villas and Their Gardens* (1904).

Painter Thomas Wilmer Dewing (P/CC/NA) arrived in Cornish in 1885 and settled in a farmhouse adjacent to the Beaman family, nearby the Platts. In 1893, Thomas Dewing painted portraits of Beaman's wife Hettie and of his neighbor, Charles Platt, as well. Soon after, Dewing became known as 'the Degas of America,' and later was included as a member of The Ten, a sobriquet stemming from the

milestone Montrose Exhibition (1898) in which ten artists were featured. Nine of The Ten were members of The Players. Dewing married Maria Richards Oakey (CC/NA) a friend of Helena de Kay Gilder (1846–1916), artist and wife of Richard Watson Gilder (P), influential editor of *Century* and Maxfield Parrish's editor for 'The Great Southwest' series and later for *Italian Villas and Their Gardens*. The Gilders were neighbors of Edith Wharton in Lenox, Massachusetts.

Helena de Kay Gilder was a young art student when she first met Saint-Gaudens. Together, in 1877, they formed the Society of American Artists in defiance of the National Academy of Design, criticized for its staid, unimaginative positions in the art world. Helena Gilder's brother Charles de Kay (P), was an influential art and literary critic for the *New York Times*. He collected MP's original art works and

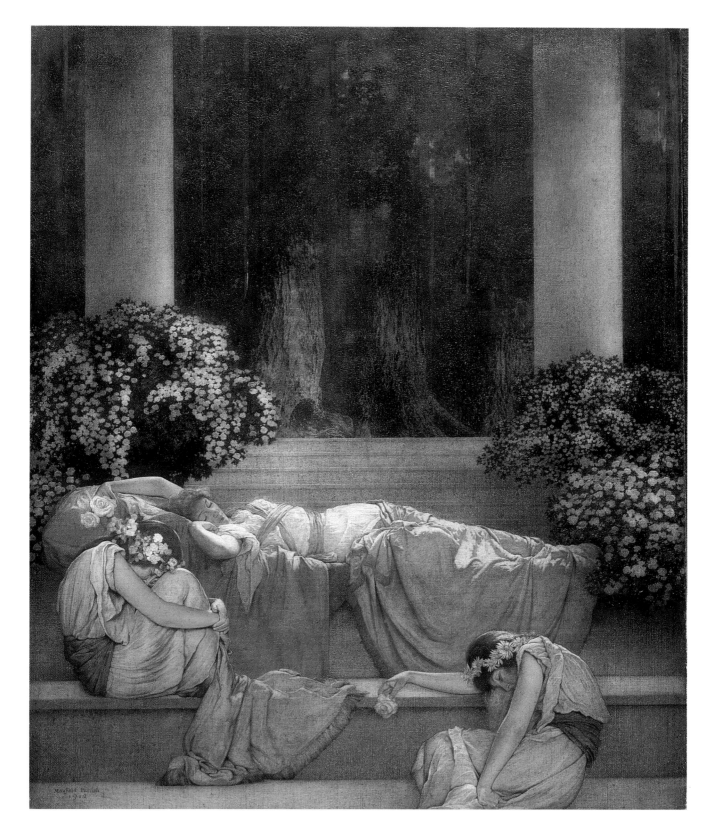

PLATE 26
Sleeping Beauty (1912)

Oil on canvas, 29¹/₂ x 24 inches (75 x 61cm)

Hearst's Magazine cover, November, 1912

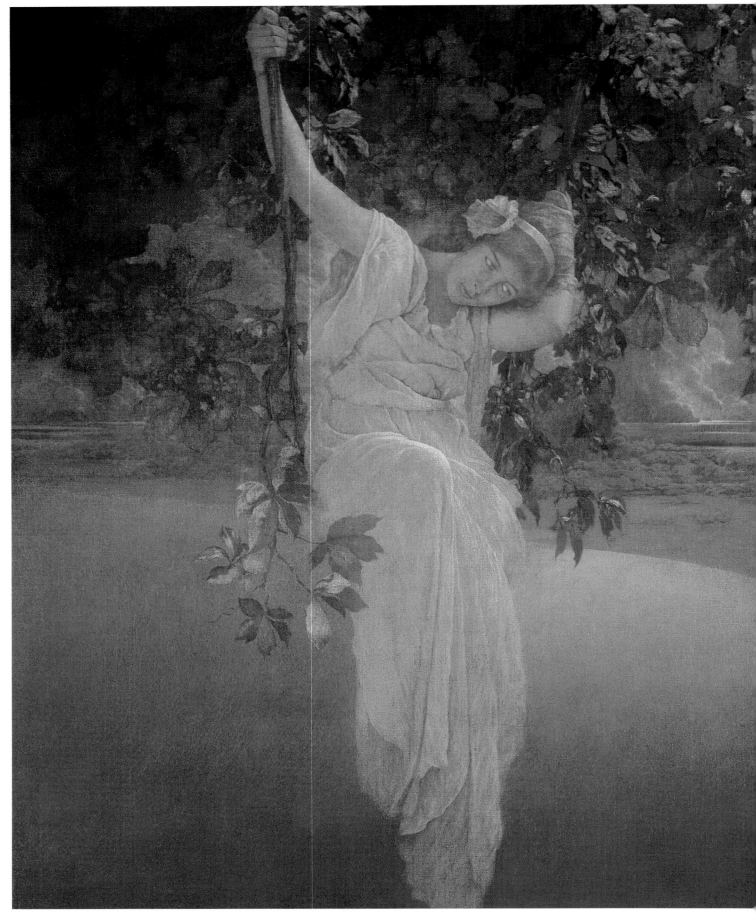

PLATE 27
Reveries (1913)
Oil on canvas, 38³/₄ x 45³/₄ inches (98.4 x 116.2cm)
Hearst's Magazine proposed cover design, May 1913

was the primary founder of the adjacent National Arts Club (an artist's and art-lover's club, the first such establishment to admit women). Helena's husband, Richard Watson Gilder, introduced Thomas Dewing to Augustus Saint-Gaudens and then later to Stanford White (P), who eventually helped Dewing sell his first tonalist painting.

In 1890, Thomas Dewing met his patron, the Detroit industrialist Charles Lang Freer at The Players Club. Freer financed Dewing's studies and travels abroad, ultimately permitting him to apprentice with James McNeill Whistler. Many of Dewing's paintings hang in the Smithsonian's Freer Gallery nearby Whistler's magnum opus, *The Peacock Room*. For the most part, the frames on the Thomas Dewing paintings at The Freer were designed and fabricated by Stanford White.

When Stanford White was a young man and without serious goals, his father Richard Grant White consulted the first American landscape architect Frederick Law Olmsted and John LaFarge (P/NA) regarding possible career choices for his son. Stanford White introduced Saint-Gaudens to John LaFarge, a painter and designer of stained glass. White, Olmsted, LaFarge, and Saint-Gaudens at one time or another worked on projects together. Such projects included the memorial to the hero of the

PLATE 28 above
Puss–in–Boots (1913)

Oil on panel, 30 x 24 inches (76.2 x 61cm)

Hearst's Magazine cover, May 1914

PLATE 29 opposite
Forest Scene from 'Once Upon a Time' (1916)

Oil on canvas mounted on masonite, 32 x 40 inches (81.3 x 101.6cm)

battles of New Orleans and Mobile Bay, Admiral David Glascow Farragut (1881), which was erected in Madison Square Park near *Century*'s offices and The Players Club. LaFarge, a great admirer of Maxfield Parrish once said of him: 'I know of no artist today, no matter how excellent, with such a frank imagination, within a beautiful form, as is the gift of Mr. Parrish.'

In 1906, Freer commissioned White to design the gallery which he was proposing to build in Washington. Soon after, the mustached White was shot dead by the enraged Harry K. Thaw, an eccentric millionaire and husband of Evelyn Nesbit, immortalized as 'The Girl in the Red Velvet Swing.' Interestingly, Parrish painted his favorite model and companion, Susan Lewin, in the work entitled 'Reveries' (plate 27), a pose reminiscent of Ms. Nesbit, a girl in classical robes, flowers in her hair, and sublimely swinging on a soft swing with vines as cords. It has been erroneously reported that White designed picture frames for Parrish's art: they knew each other from The

Players, but alas never worked collaboratively. After White's untimely death, Freer commissioned Charles A. Platt to design his Washington gallery building which today houses his magnificent art collection under the able stewardship of Director Dr. Milo Cleveland Beach. Platt later planned the Italian reconnaissance jaunts for Maxfield Parrish, the Pennells, and other Cornish cronies and Players.

Charles Lang Freer visited Cornish a number of times, and in 1894 the Dewings held an oriental masque in his honor at High Court, the country home designed by Platt for poet Annie Lazarus (CC). Dewing, Platt, Stephen M. Parrish and Kenyon Cox (P/CC/NA), shared a love of Italianate gardens, Japanese prints and Whistleresque interiors and the party therefore had an oriental theme. The masque was held in the villa-like Platt gardens with cypress trees lining the walkways, and Japanese lanterns: it was a great and memorable success.

Percy MacKaye (P/CC), was known by his many friends as 'The Good Gray Poet of Gramercy Park', one of

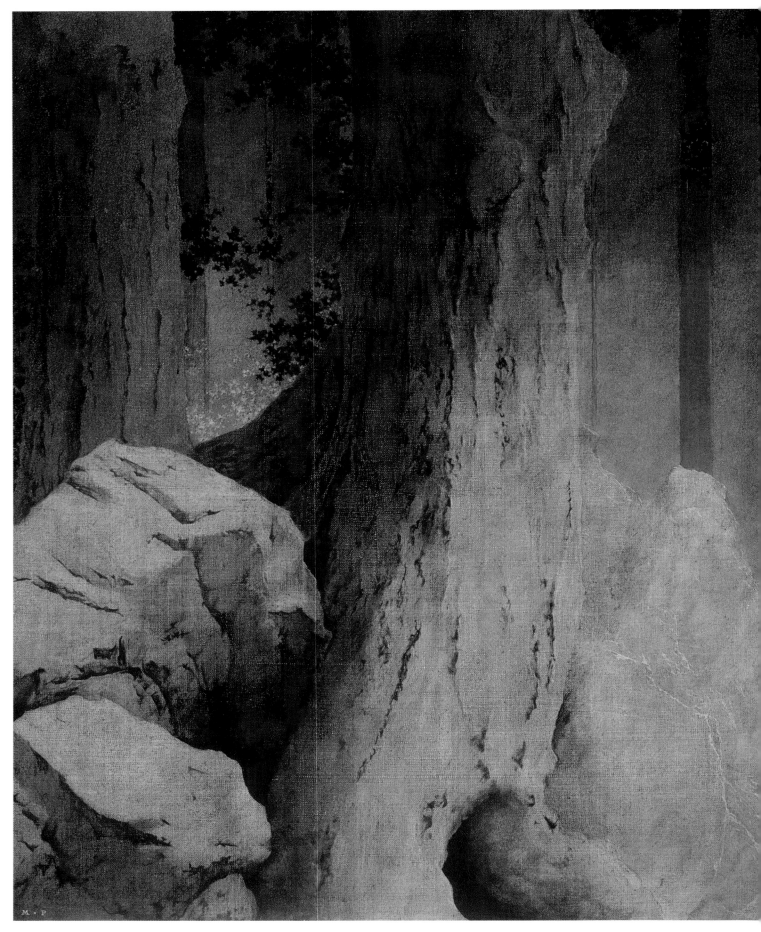

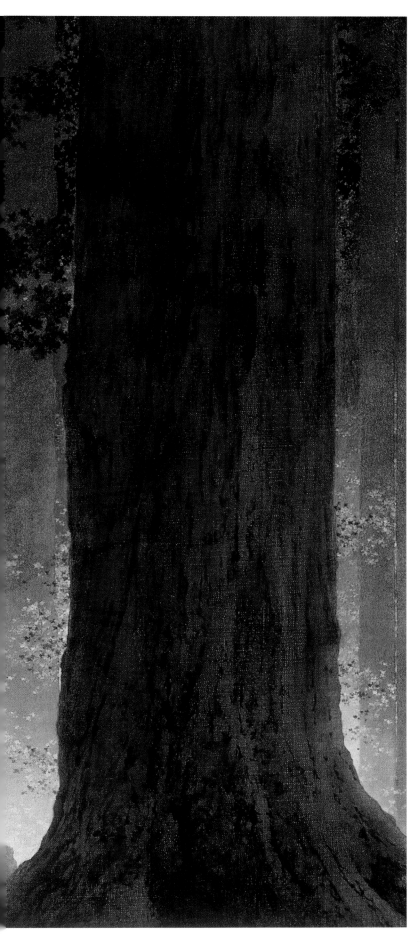

PLATE 30
Forest Drop ('Once Upon a Time')
(1916)
Oil on panel, 32 x 40 inches (81.3 x 102cm)

the most influential members of the Cornish Colony. He had been inspired by the Freer masque to present the anniversary pageant *A Masque of 'Ours': The Gods and the Golden Bowl* authored by Louis Evan Shipman (P/CC) in 1905. MP designed the costumes, posters and programs for this event as well as the Comic Mask (plate 11), the only sculptural work he ever created. The occasion was the most celebrated event in the history of the Cornish Colony. MacKaye often socialized with Parrish and referred to dinners at The Oaks as 'chick-a-dee dinners' – insider language meaning those dinners attended by year-round Cornish folks. Virginia Colby mentioned in *Footprints of the Past* that MacKaye remarked, 'We had a wonderful dinner (of squabs, wines, etc.) as we always do there (at The Oaks). The witticisms just flowed from Mr. Parrish's lips! He is a very brilliant fellow, hardly a moment when these sallies are not amusing and delighting.'

While visiting the Whistler Exhibition at Boston, Parrish was introduced to Isabella Stewart Gardner, powerful art collector and proverbial Boston Brahmin. Mrs. Gardner collected the works of Botticelli, Degas, Della Robbia, LaFarge, Manet, Matisse, Raphael, Sargent, Titian, Whistler, Dennis Miller Bunker (P/CC/NA), and Paul Manship (P/CC/NA) for the Venetian villa which she built on the Olmsted-design, The Fenway.

Elizabeth (CC) and Joseph Pennell (P/CC/NA),

PLATE 31

Landscape Study for the backdrop of the Plainfield, New Hampshire Town Hall stage set (1916)

Oil on panel, 16¼ x 23 inches (41.3 x 58.4)

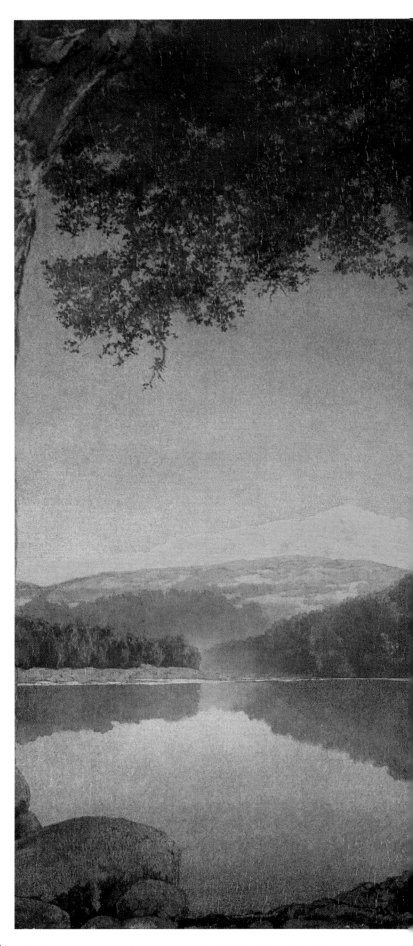

biographers and artists, authors of *The Life of James McNeill Whistler*, knew Stephen M. Parrish from the Philadelphia Society of Etchers, which they had co-founded in 1880. Stephen's studio on Chestnut Street was close to the Pennell's and very near to that of portrait artist, Cecilia Beaux (NA), a great fan of Maxfield Parrish. Perhaps not so coincidentally, Beaux painted a portrait of Richard Watson Gilder in 1902, the year in which he commissioned Parrish for the *Italian Villas*, as well as eleven other portraits of the Gilder family including Helena de Kay Gilder.

Winston Churchill (P/CC), Parrish neighbor and close friend, wrote the best-selling novel *Richard Caravel* (1899) which sold over a million copies. Churchill was known as 'the most popular fiction author in America between 1900 and 1925,' according to *Publisher's Weekly*. Charles A. Platt designed Churchill's Cornish home, which was used as the Summer White House between 1913 and 1915 by President Woodrow Wilson, the 28th President. One of the major reasons the Wilsons came to Cornish was for Mrs. Wilson to take *plein-air* painting lessons and to be near Maxfield Parrish and Platt.

On any given day, one could find Richard Watson Gilder and Charles Scribner (P) at The Players. *Scribner's Magazine,* founded in 1888, quickly became one of the three most popular magazines, along with *Harper's Monthly* and *Century*. It was for these three magazines that Parrish first flourished as an illustrator and made his national

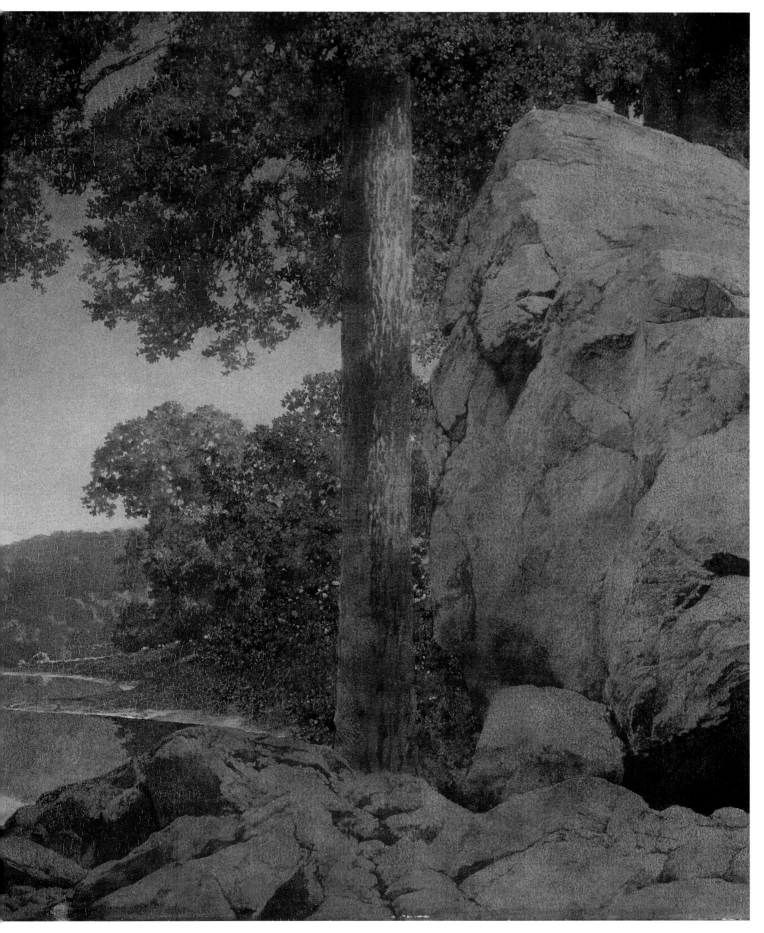

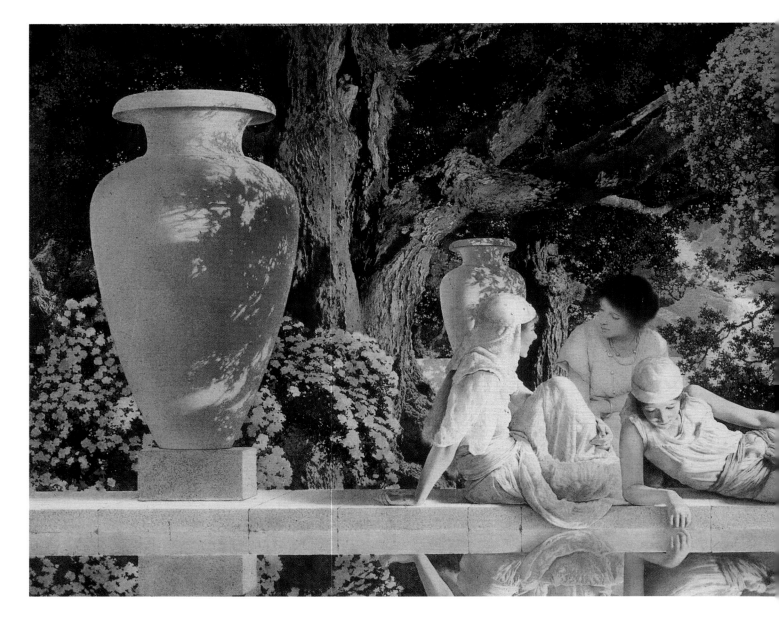

reputation. The first Scribner's office was about 20 blocks from Gramercy Park, and it is clear that the early success of *Scribner's Magazine* had a direct connection to The Players.

Joseph H. Chapin (P), art editor of *Scribner's Magazine* worked with MP on Eugene Field's *Poems of Childhood*, their business and personal relationship enduring for 25 years thereafter. Chapin wrote an often-quoted letter to MP on Dec. 27, 1901, stating that the artist Edwin Austin Abbey (P) had informed him that the German Emperor 'is greatly interested in your work, after seeing *The Golden Age* published in Europe by John Lane.' The Emperor ordered a dozen copies of the Parrish book for his personal library and to give as gifts – MP's reputation was now not only secure, it had become international.

Edward W. Bok (P), editor of the *Ladies' Home Journal* was a Parrish client beginning in 1896. In addition to

covers, art prints, advertisements and murals, Parrish designed two unique projects for Bok at the Curtis Publishing Company Building in Philadelphia. The first extraordinary project was the incredible series of 18 murals entitled *A Florentine Fete* (plates 23, 24, 25 and 52). The paintings were each 10ft 6 inches high and most averaged 5ft wide, although some were much wider. The second project was the legendary, overwhelmingly beautiful 15 x 49ft mosaic, entitled *Dream Garden*, executed in favrile glass by Louis Comfort Tiffany (P). This project stands as the only collaboration ever undertaken by Parrish, while Tiffany worked with several other artists and architects over the years.

Ray Stannard Baker (P), author of 'The Great Southwest' series of articles, which appeared in *Century* magazine, put in a word with the magazine on Parrish's

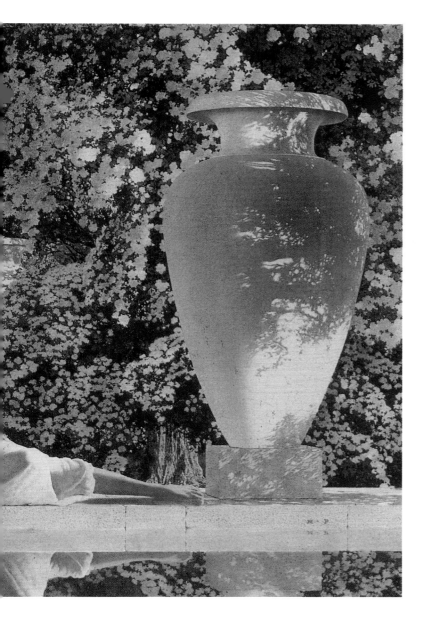

PLATE 32
Garden of Allah (1918)
Oil on panel, 15 x 30 inches (38.1 x 76.2cm)
Decoration for gift boxes of Crane's Chocolates

says, a companion article to that.' The letter was addressed to Brinton at The Players, as he was resident there at the time. It has been said that Brinton, shortly after joining the Club (1900), suggested to MP that The Players would be 'a great place to meet the swells.' However, there is some dispute as to exactly which year Maxfield Parrish joined The Players. Some say that he was first invited to join by Brinton, and others say it was earlier or later. The Club records indicate that Parrish was a member until 1935, but little information exists as to when he actually joined.

Parrish met many other artists at The Players, such as Will Bradley (P), whose artistic style and graphic technique were more similar to Parrish's than any other artist. In fact, some have said that Parrish's style was 'more like Will Bradley's than Will Bradley.' Parrish respected A. Stirling Calder (P/NA), the sculptor and father of sculptor Alexander Calder, and enjoyed years of camaraderie in their meetings at 'that certain club.' Stirling Calder and Mark Twain usually sat at an artist-publisher-editor round table for lunch, mixing creative talent with discerning expertise and taste; luncheon companions invariably included the likes of Gilder, Underwood, Drake, and political cartoonist Thomas Nast (P), while Dewing, Platt, MacMonnies, Saint-Gaudens, White, and Parrish sometimes joined each other at the next round table – a culinary circle of sculptors, architects and painters. Other Players figures of consequence

behalf, stating: 'There is an understanding of the perspective of these mountains and plains that lives in the mind of an artist of imagination, and that strikes the imagination of those who look upon them.' Baker first met MP in the main salon of The Players. On that very first occasion they shared a bottle of red wine, a bottle of sherry and topped off their tanks with a half-bottle of oporto and some cigars. They became good friends and collaborated in projects for the *Century*.

In 1911, Robert Underwood Johnson (P/CC), associate editor of *Century* magazine, wrote to Christian Brinton (P), editor of *The Critic* and Parrish's roommate at Haverford, regarding an upcoming article on Parrish, 'We are going to have a somewhat similar article on Whistler as a decorator by the Pennells, with a lot of his work not known to the public – and this would be, as A. W. Drake

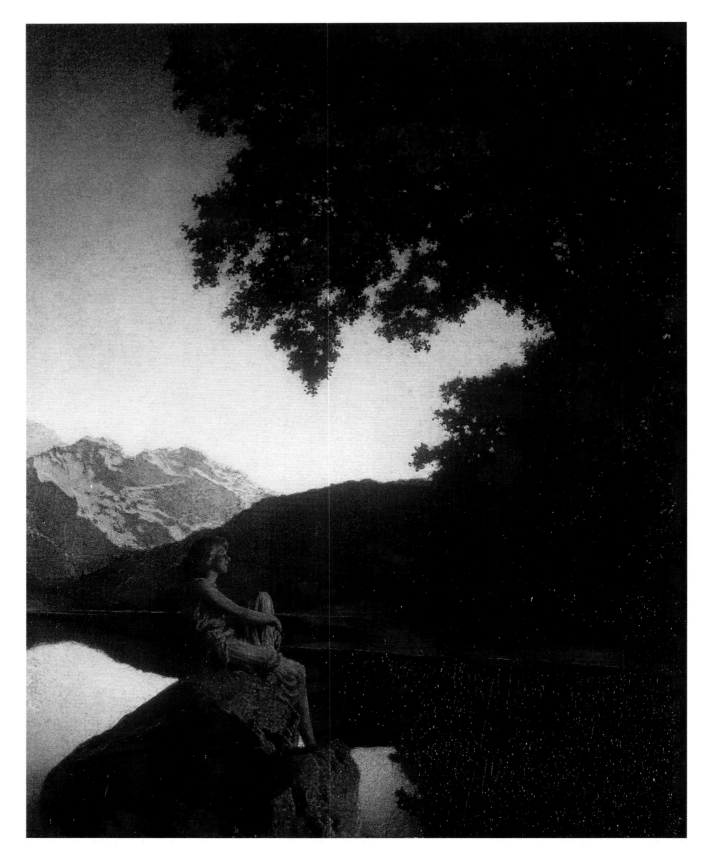

PLATE 33
Girl by the Lake (1918)
Oil on board, 10 x 8 inches (25.4 x 20.3cm)

to Parrish were L. Frank Baum (P), Herbert D. Croly (P/CC), Richard Butler Glaenzer (P), James Montgomery Flagg (P), Harrison Fisher (P), Childe Hassam (P/NA), Walter Lippmann (P/CC), J. Pierpont Morgan (P), Eric Pape (P/CC), Howard Pyle (P/NA), George Bellows (P/NA), Frederic Remington (P), Frank Schoonover (P), John Twachtman (P), and Arthur Whiting (P/CC). The Cornish Colony included such other luminaries as John White Alexander (NA), George deForest Brush, Judge Learned Hand, Willard Leroy Metcalf (P/CC), Everett Shinn, Abbott Thayer (NA), and William Zorach.

The only art work Parrish is known to have completed for The Players is a poster entitled, 'Pipe Night December 5, 1915,' which he painted in honor of his old friend, the cabaret singer David Bispham (P). In 1914, Parrish, Bispham and Brinton were simultaneously awarded honorary degrees at Haverford College.

One only has to review Parrish commissions to see that the important clients and associates were members of this powerful legion of luminaries in the worlds of art, business, and letters. It can not be emphasized enough how influential both The Players Club and The Cornish Colony were on Parrish's career and lifestyle.

THE ILLUSTRATIONS: MAGAZINES, POSTERS AND BOOKS

Maxfield Parrish's career was destined to flourish, firstly due to his unusual talent and imagination; secondly due to his contacts and art successes; and thirdly due to the

awards and abundant public recognition lavishly spread upon his shoulders from the very beginnings of his sixty-five-year career.

When MP audited Howard Pyle's illustration drawing classes at Drexel Institute in 1895 (the first organized illustration courses), that great illustrator-teacher, the 'Father of American Illustration,' immediately recognized the Parrish facility with pen and pencil. Pyle suggested that Parrish did not need to take the class and after two weeks convinced the young art student to actively pursue illustration as a career. Illustrators were in great demand and it seemed a waste to Pyle that such an extraordinary talent should focus on fine art rather than be 'directed towards a more useful pursuit.' Pyle and his coterie considered fine art a leisure quest or a hobby. Pyle encouraged Parrish to further explore the field, to use costumes for authenticity when portraying period scenes and then to enter competitions in order to gain the attention of magazine art editors. Parrish did everything suggested, religiously. Within the year, MP won his first commission for a major magazine cover for the 1895 Easter number of *Harper's Weekly* (plate 3), and he continued to illustrate for *Harper's* for a decade thereafter.

Whilst enrolled at the Pennsylvania Academy, MP submitted a design to the school's Poster Show and won against stiff competition. Months after that, he won second prize (to the already famous illustrator, J.C. Leyendecker) in a poster design competition; but this time it was for the number one magazine in the U.S.A. – *Century*. The reason

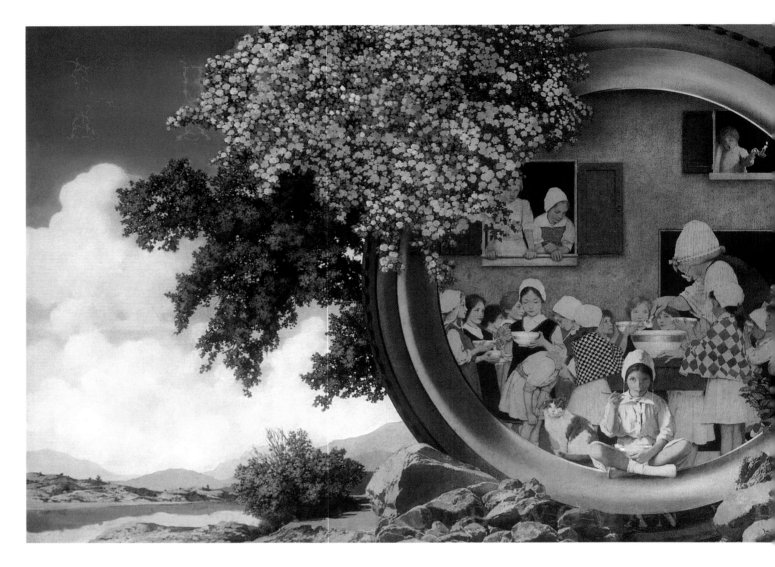

given for his having received 2nd prize rather than 1st was that Parrish used more colors than the rules permitted. Nevertheless, the result was stunning and the jurors felt obligated to award a prize in spite of this infraction. Later the *Century* poster was published in the noted French publication, *Maître de l'Affiche*, next to the work of Count Henri Toulouse-Lautrec.

In 1897, Parrish was inducted into the Society of American Artists and shortly thereafter illustrated his first complete book, L. Frank Baum's *Mother Goose in Prose*. The *Century* commissions began to flow continuously and did so until 1917.

Life magazine commissions began in 1899 and continued for twenty-five years (see plate 35). Parrish was not only doing something right, but was clearly also in the right place at the right time. Over succeeding years from 1900 until the early part of the second decade of the 20th century, he secured his reputation by creating a portfolio abundant in the best of American illustration, perhaps the

best illustrations in the world.

Book illustrations continued to be commissioned for John Lane: The Bodley Head, in London, which included 'The Olympians' for *The Golden Age* by Kenneth Grahame (plate 8) and work for Richard Glaenzer's *Poems of Childhood* – 'Seein' Things At Night' (plate 9), William Shakespeare's *The Tempest* – 'Prospero in Golden Sands' (plate 21), and others.

The years from the turn of the century until 1925 represent Parrish's greatest output of book and magazine illustrations. His prolific book illustrations seem to have had the most lasting impression on his audience, partly due to the fact that the audience was essentially made up of children.

Wide recognition was gained not only from the book illustrations but also from the advertisements *for* the books, which appeared in magazines and on posters everywhere one looked. The world was fast changing and marketing books with advertisements had just begun. In fact, the first

PLATE 34
There Was an Old Woman Who Lived in a Shoe (c.1920)
Oil, 24 x 58¾ inches (61 x 149.2)
Proposed Fisk Tire advertisement (unpublished),
January 1920

advertising agencies were being established at the time and young admen were seeking strong images to attract attention to their clients' products. Parrish gave this newly born industry exactly what it needed – powerful, colorful and dramatic images such as 'There Was an Old Woman Who Lived in a Shoe' (plate 34 above). Maxfield Parrish was the creator of dynamic advertising images which reached out across America to hold a diverse public attention (see Jell-O Ad, plate 1). Any advertiser who availed himself of a Parrish image was assured of business success and increasing customer demand.

About this time and at the suggestion of his father, MP hired Susan Lewin, a fifteen-year-old farm girl from Cornish to help with the family so that he could keep up with the landslide of commissions. Susan's job was at first to help with Dillwyn (born 1904) and to assist Lydia with light housekeeping. Within a matter of weeks, MP seconded Susan into the role of artist's model, a role she fulfilled well. Almost immediately he recognized an innate beauty in this

country lass and her position within the family was redefined. After the other Parrish children were born, Susan asked for more help and other local girls were brought to The Oaks to care for Dillwyn's younger siblings, Max, Jr. (born 1906), Stephen (born 1909), and Jean (born 1911).

In 1899, Parrish completed illustrating Kenneth Grahame's book, *The Golden Age*, with 'The Blue Room' (plate 7) and a few years later, its sequel *Dream Days* (1902), deemed the best-selling books of their day. It was obvious that the Parrish illustrations played no small role in this success. The graceful decorations on the book jackets, the covers, frontispages, tailpieces, headings and endpages were coveted by everyone who saw them. Each book was a virtual library of Parrish-created fantasy. Not surprisingly, many book publishers were in the lucrative business of magazine publishing, men such as William Randolph Hearst (see 'Jack the Giant Killer' and 'Puss-in-Boots', plates 19 and 28), Charles Scribner, and of course Richard Watson Gilder. It was only logical to utilize the same illustrator for

PLATE 35 opposite
Morning (1922)
Oil on panel, 19⁵/₈ x 15 inches (49.8 x 38.1cm)
Life magazine Easter cover, April 6, 1922

PLATE 36 (pages 52 and 53)
Daybreak (1923)
Oil on panel, 26 x 45 inches (66 x 114.3cm)
House of Art, 1923

both books and magazines, especially when the sales were brisk with a particular illustrator's work. The book publishing successes bred more magazine publishing successes and both bred more advertising. Such an entire range of illustration endeavors was what Parrish enjoyed best which he boasted was not really work, but 'mighty good fun.'

THE ILLUSTRATIONS: MURALS, STAGE SETS AND ADVERTISEMENTS

More commissions flowed and new clients loomed at every turn. Fortunately, Pyle had been right and this artist did not suffer as many so-called fine artists did – the starving artist in a dingy studio.

New clients appeared daily at Parrish's door with unquenchable thirsts for his illustrations. Some of these new clients included *Ladies' Home Journal*, *Life*, and *Colliers* (see 'The Tramps Dinner', for its Thanksgiving number, plate 14, also plate 17). *The Ladies' Home Journal* was published in Philadelphia and the editor, Edward W. Bok, was well aware of Parrish from The Players and from the artist's wide-ranging reputation. Bok commissioned Parrish to illustrate many magazine covers and articles, notecards and subscription brochures, and then he commissioned him to paint 'A Florentine Fete' (1911–1916) for the girls' dining room at the Curtis Publishing Company Building. 'A Florentine Fete' is recognized by most experts to be

Parrish's greatest single art work.

Among such unique commissions, Parrish also designed for his beloved Plainfield, New Hampshire, Town Hall (see landscape study for the backdrop of the Plainfield Town Hall stage set, plate 31). These feats were an unusual combination of art works created by a single artist whose career began with posters of 13¹/₂ x 8³/₄ inches (34.3 x 22.2cm), ranging to magazine covers with original artworks, usually 28 x 18 inches (71.1 x 45.7cm) or small advertisement layouts such as the one for Jell-O puddings or a 49ft (15m) long mosaic such as the one gracing the walls of a corporate office building across the street from the Liberty Bell.

The years between 1900 and 1925 represent the development of Maxfield Parrish as the world's preeminent book illustrator of the 20th century. This culminated, in 1925, with his last book illustration project, Louise Saunders' *Knave of Hearts* (plates 2, 37, 38, 39 and 40).

With the several building murals and theatrical set commissions completed and pushed aside, Maxfield Parrish endeavored to meet publishing schedules and to satisfy his editors on a continual basis for many, long years. There was more than enough work to go around with a groundswell of up-and-coming publications. Parrish thrived and he gracefully rode the crest of the wave which he created. He was consequently the single most popular artist/illustrator at the beginning of the 20th century.

In the midst of such daunting commercial successes with

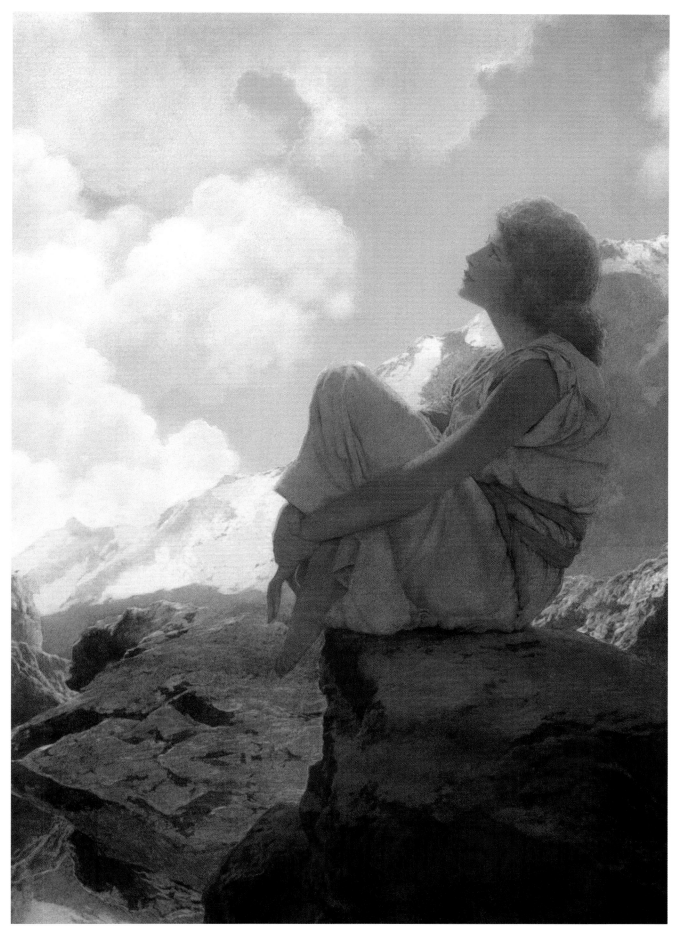

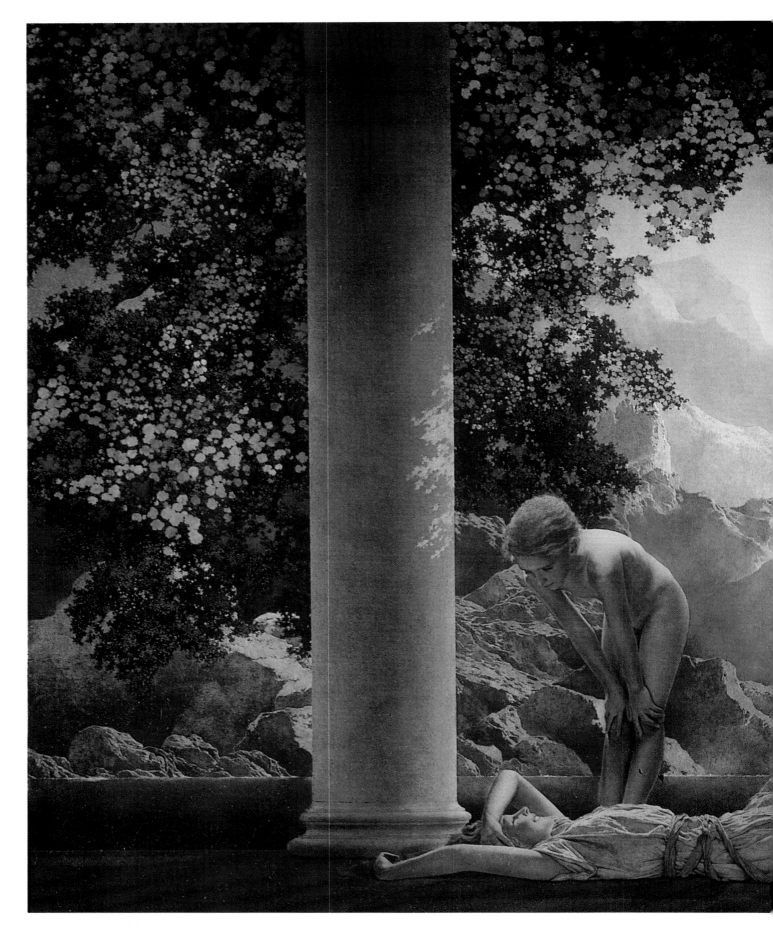

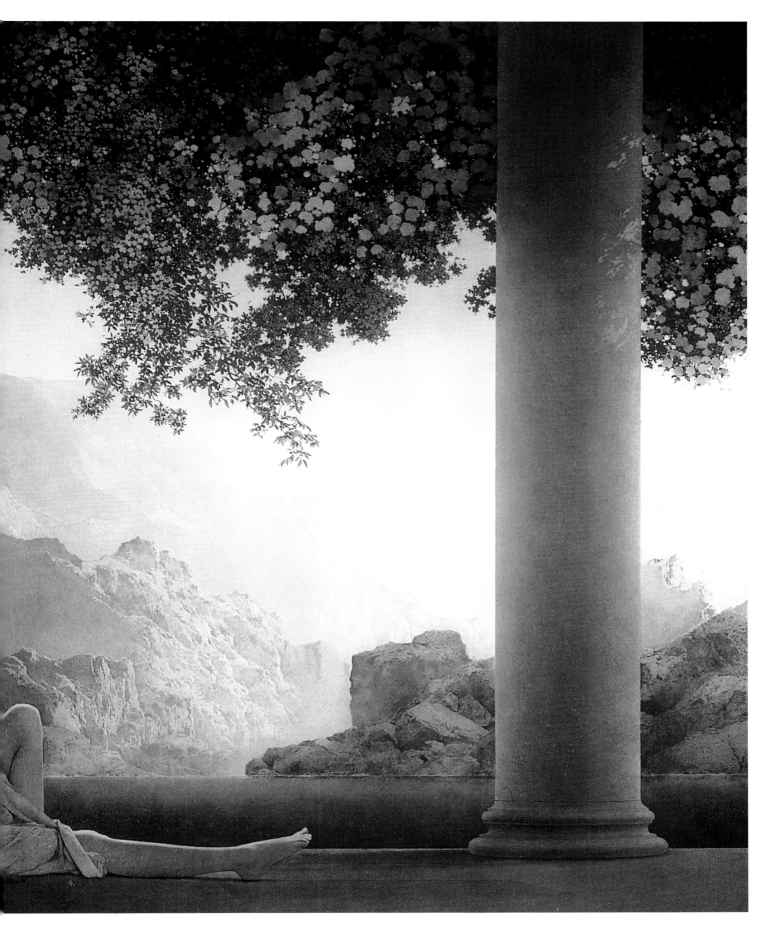

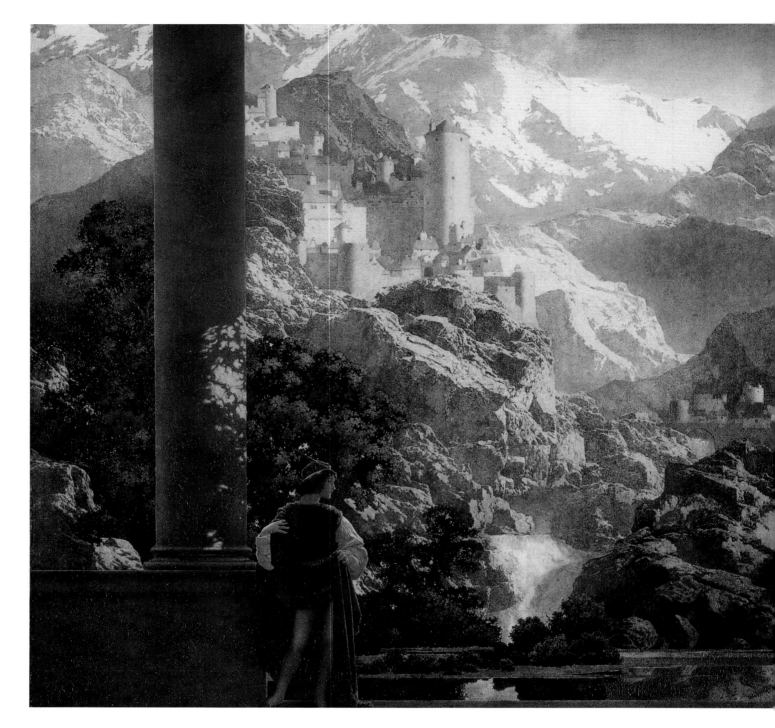

both book and magazine illustrations, Parrish discovered New York in a new way. He had frequently traveled to the city to meet with publishers, art directors and clients, and often spent endless hours at The Players. As the years ticked away, he grew to enjoy the dichotomous role of an artist stashed away in an art colony in the hills of New Hampshire in contradistinction to the role of bon vivant, handsome and gallant Hollywood 'man about town'. His lifestyle in New York City caused his Cornish lifestyle to pale, for in the city he caroused with actress Ethel Barrymore at the Algonquin bar, lounged in smoke-filled parlours at The Players Club and spent untold hours relaxing at the National Arts Club.

Finally in 1918, after some years of increasing business, recognition and wealth, he rented a studio in New York City and brought Susan Lewin 'from the hills,' for a nine-month stint in the city. His greatest advertising commission had just been awarded, the Edison Mazda Division calendar series for the fledgling General Electric Company (plate 41) which ran from 1917–1932. He felt flushed with success, money and fame; Maxfield Parrish was a few years short of fifty and Susan was in her prime, a few years short of thirty. The New York scene offered even more to the middle-aged artist, it

PLATE 37

Romance (1922)

Oil on board, 21¼ x 36½ inches (54 x 92.7cm)

Louise Saunders' *The Knave of Hearts*, 1925, Charles Scribner's Sons, NY

THE ILLUSTRATIONS: ART PRINTS AND A NEW DIRECTION

By 1917, MP had been awarded the coveted Architectural League of New York's Medal of Honor. Parrish had first won honorary degrees in 1905, at Haverford College, as well as awards from the National Academy of Design, and a short decade later his name became a household word. He fine-tuned his business acumen and enjoyed referring to himself as 'a mechanic who loves to paint.' MP's earliest successful venture with art prints, a major departure from previous clients in publishing, derived from a relationship with Clarence A. Crane, a Cleveland chocolate candy manufacturer. Mr. Crane commissioned a box cover in 1915 with the same image to be issued as a premium gift – an art print suitable to be framed. A coupon was enclosed within the candy box and for 25 cents the print would be mailed to the candy lover. Tens of thousands responded. This resounding success engendered repeat issues of other images created specifically for the Crane Chocolate Company. Parrish relished this new role, creating images from subject matter which he decided upon himself and always without the severe constraints of a publishing deadline. It was a new world with a new formula for success, and it was his call.

That year, Parrish painted 'Omar Khayyam' for Crane's and in 1918, 'Garden of Allah' (plate 32), which immediately became a favorite amongst Parrish aficionados.

offered him immortality. He was winning medals of honor and art collectors were hounding him to buy the illustration originals. Susan longed for the woods and felt uncomfortable amidst the effete New York crowd. She managed to entice him away from the glittering world of society and fame to return to a simpler world of fireside chatter and quiet evenings at home, in the studio building at The Oaks. From then onwards, Susan 'protected' him from tourists and fans, even from Cornish friends when they called for a visit. She selected whom he should see and for how long they would stay.

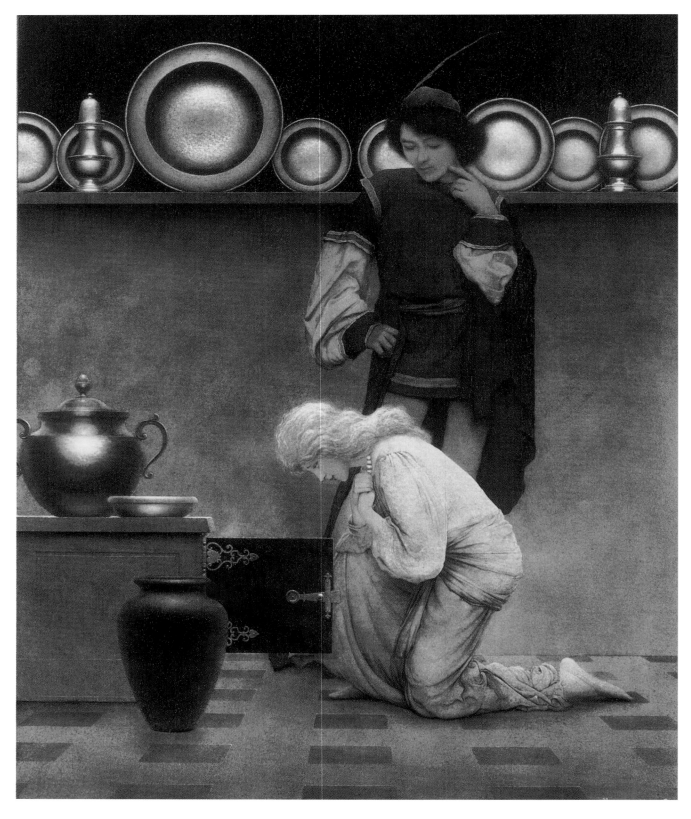

PLATE 38

**Lady Violetta and the Knave Examining
the Tarts** (1925)

Oil on board, 19¹/₄ x 15 inches (49 x 38.1cm)

Louise Saunders' *The Knave of Hearts*, 1925

PLATE 39

Entrance at Pompdebile: King of Hearts

(1925). Vintage Print

Louise Saunders' *The Knave of Hearts*, p.15, 1925

Book Plate

PLATE 40 left
Study for bookplate for *The Knave of Hearts*
(c.1925)
Watercolor, pencil and pen, 14¹/₈ x 15⁵/₈ inches
(35.9 x 39.7cm)
Mock-up for Louise Saunders' *The Knave of Hearts*, fourth of
nine studies

PLATE 41 opposite
Moonlight (1932)
Oil on board, 32⁵/₈ x 22³/₄ inches (82.9 x 57.8cm)
General Electric Edison Mazda Lamp Calendar, 1934

It was at this juncture that Clarence Crane arranged for an introduction to the House of Art to handle orders for prints. After the introduction, Parrish quickly developed a new business relationship with the House of Art, the distribution arm of the art print publishers Reinthal and Newman. The relationship was destined to last for twenty years, making both MP and the publishers very rich men. As a result of Maxfield Parrish's images, Crane became the most successful chocolate distributor and Parrish the most successful illustrator – a perfect combination. Ironically, it was this relationship which enabled MP to give up advertising commissions altogether; he had already ceased doing books, but now also advertising and magazine work, and he launched a new career – images for sale as art prints. Parrish was aware that his original intuition to *only sell the rights to use an image once* would prove to be very lucrative, and after the initiation to the art-print business other projects loomed, projects which offered him the ability to simply sell the reproduction rights to images in his archives, exactly what he had always envisaged doing.

The most famous of these art-print images was painted in 1922, the mother of all art prints, 'Daybreak' (plate 36). It remains without question the most reproduced art print in history. Maxfield Parrish, flushed with the success of 'Daybreak', immediately painted 'Romance' (plate 37) for the end papers of the *Knave of Hearts* book. He then urged

his publishers to release 'Romance' as an art print as well, feeling that it was 'a better painting with more illumination' than 'Daybreak'. He was correct: it is unquestionably a stunning painting with more depth and character than its more famous sister work.

THE ILLUSTRATIONS: THE CALENDAR LANDSCAPES (1930–1960)

Parrish glided through the first half of the twenties decade basking in the glory of his earlier works; but his focus had changed to marketing images as art prints. He concentrated primarily on selling reproduction rights in varying sizes and for various applications, such as on calendars, notecards and greeting cards. As a case in point, in 1934, 'Moonlight' (opposite), which he had painted in 1932, appeared as a calendar completed for the Edison Mazda division of General Electric: the reality was that it was created for several other uses first!

Over the next years (1937–1942), Parrish re-released many previously painted images; for example, to the Thomas D. Murphy Company for use on their calendars. Suddenly in the early 1930s, about the same time as the Murphy relationship had taken hold, his creative dynamism waned and he was depressed at all the copyists. Simultaneously, the public's thirst for his work had been quenched. Fortuitously, Maxfield Parrish had just established

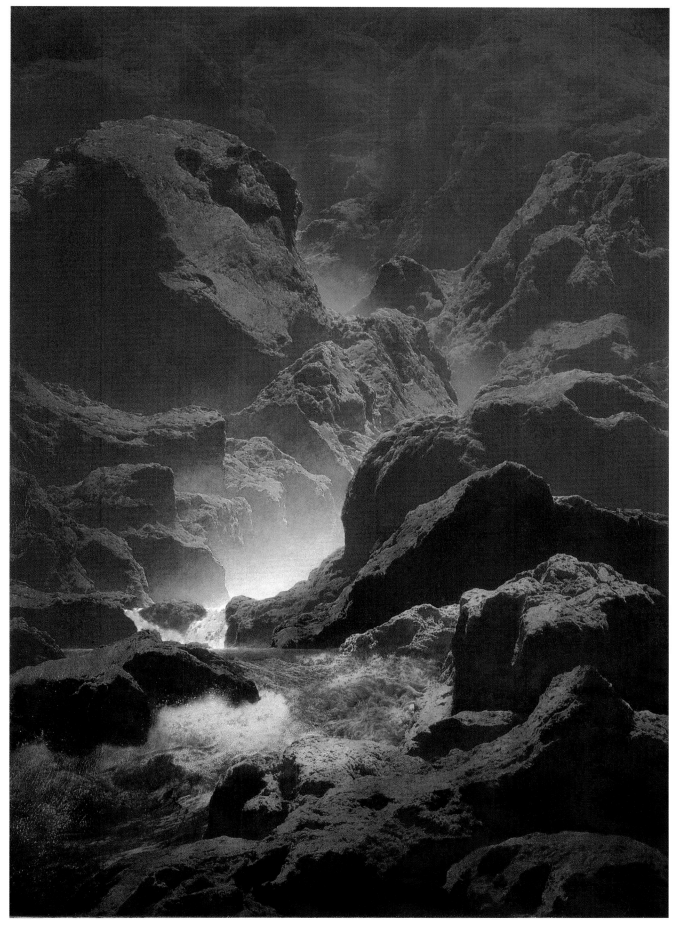

a working relationship with the Brown and Bigelow Company in Minneapolis. The new arrangement enabled Brown and Bigelow's art director to visit the artist in Cornish and to select images for a one-time-only use, for calendars and greeting cards. This new business enabled MP to undertake landscape paintings from 1936 until he stopped painting in his 90th year. As with the Murphy calendars, the Brown and Bigelow images were earlier paintings, or were images he just felt like doing; they were not works for hire. Brown and Bigelow re-released some of these images much later, assigning them new titles. They simply reused the images under license from Parrish and later from his estate through Maxfield Parrish, Jr. Today, The Maxfield Parrish Family Trust carries on the tradition by licensing Parrish's images.

It is daunting to note how much MP followed his father's footsteps when he turned to landscape painting in 1930. Although his popularity had waned with the proliferation of art prints and calendars, the greatest element affecting his popularity was the advent of copyists imitating his style. The marketplace was overrun with both Parrish images and Parrish copyists' images – a veritable flood.

Parrish remarked more and more frequently how important it was to have a view of nature on one's wall, rather than anything else. Landscape paintings were indeed

'windows on the world.' He had a vision of himself remaining in Cornish until the very end and painting magical scenes of imaginary landscapes. These landscapes were fantasy composites (created from small rocks transformed photographically into mountains) with juxtaposed building elements and highly detailed trees balancing the views. These latter-year landscapes are perhaps his most popular images. He had retreated into his own world in Cornish, away from the copyists, the critics and the fans and invented landscapes, many as fantastical as his fairy-tale images.

THE ILLUSTRATIONS: EXHIBITIONS AND AUCTIONS

In 1925, the New York art gallery Scott and Fowles held the first major exhibition of Parrish's art works. The originals from many of his earlier commissions were put on display and amazingly everything was sold. Rarely does that happen, and it was heartening to the artist since the art world had previously deemed illustration to be a 'lesser art,' 'commercial undertakings' and 'not worthy of critical review or exhibits.' Yet quite to the contrary: each time an exhibition was held of his paintings, it invariably sold out.

Since Parrish enjoyed keeping his work in his private archive, such sales exhibitions at Scott and Fowles disturbed him at their conclusions. He always regretted selling 'his babies.' Thus, such sales exhibitions grew farther and farther apart. Parrish did not need the money and consequently he ultimately chose not to sell any paintings. Once in a while he would give one away. He loaned a painting to the 'girls at the bank' (Windsor, Vermont), for treating him well, but it too was a 'loan' meant to be returned one day. He put conditions on the loan, 'as long as the bank is under the same ownership and the girls are there.' About this time, he destroyed nearly all of his studies, deeming them neither saleable nor valuable in any way.

Parrish enjoyed quipping to neighbors and young aspiring artists that 'when I paint a painting, I sell it four times!' He explained that, 'first I sell the rights for a greeting card, then a calendar, and next an art print, and then finally I sell the painting.' Comparing himself with other artists and illustrators, he commented further that other artists paint a picture and 'just sell it once!' Not a surprising statement for one of the first artists to copyright his works and perhaps one of the very first artists to make clear contracts with the clause 'for one-time use only.'

In 1964, there were two exhibitions of his work which pleased the aged artist immensely; an exhibition in nearby

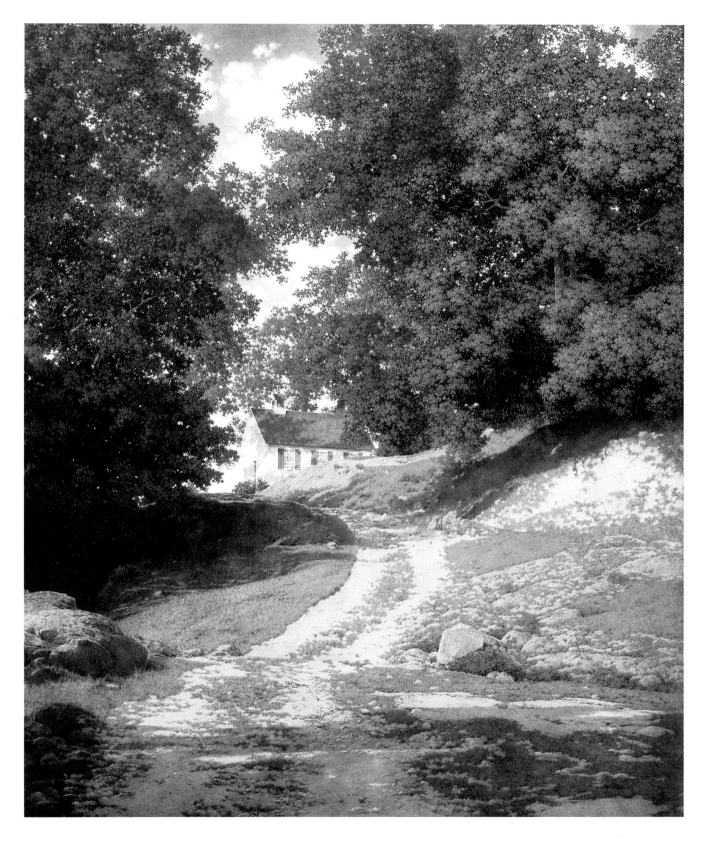

PLATE 42 opposite
Belles Lettres (1934)
Oil on panel with collaged wooden box, 19 x 13¹/₈ inches
(48.3 x 33.3cm)

PLATE 43 above
The Country Schoolhouse (Village School House) 1937
Oil on panel, 30 x 24 inches (76.2 x 61cm)

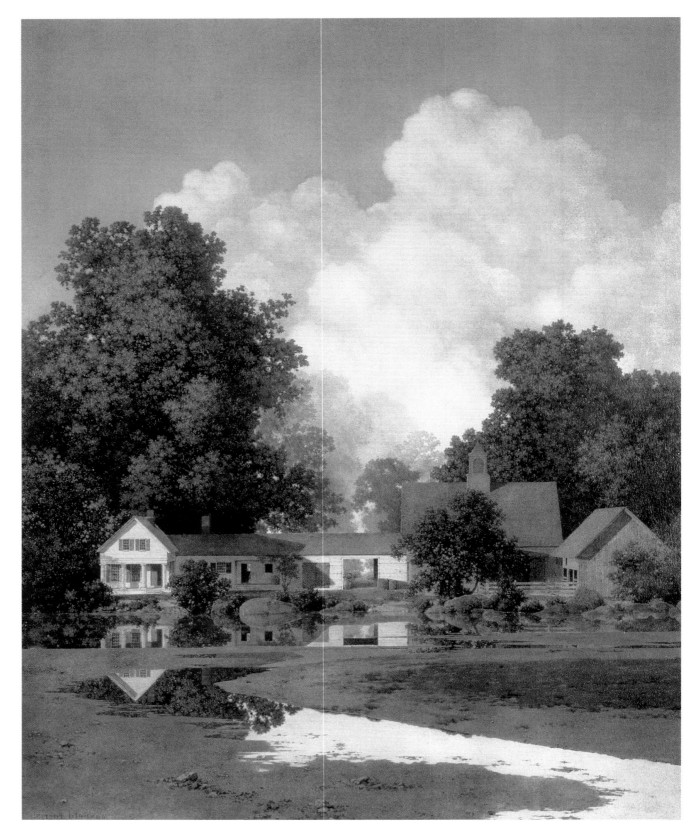

PLATE 44
Sunup (Little Brook Farm) 1942
Oil on panel, 23 x 18 inches (58.4 x 45.7cm)

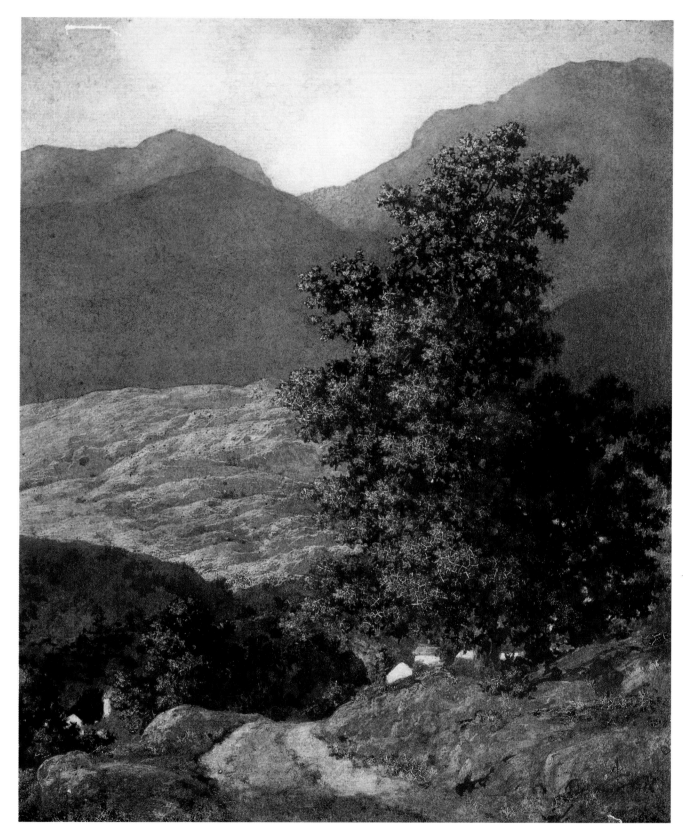

PLATE 45
Valley of Enchantment (1943)

Oil on panel, 22³/₄ x 18¹/₄ inches (57.8 x 46.4cm)

Brown and Bigelow calendar, 1943

PLATE 46
Good Fishing (1945)
Oil on paper laid down on masonite, 23 x 18¹/₂ inches
(58.4 x 47cm)

Vermont at Bennington College and then more importantly a major exhibition at the newly opened (and now defunct) Huntington Hartford Gallery of Modern Art in New York City. In 1965, the Metropolitan Museum of Art, arguably America's greatest art museum, bought a Parrish painting, 'The Errant Prince'. This pleased him greatly, for at least one of his paintings now 'rested at The Met', an accomplishment few illustrators can yet claim. Later in the same year, a Parrish exhibition was held in nearby Cornish at sculptor Daniel Chester French's estate, Chesterwood. In 1966, the year in which Parrish died, an exhibition was held at the George Walter Vincent Smith Museum in Springfield, Massachusetts, just south of Cornish. Perhaps he welcomed all this late recognition, but it is more likely that he preferred not to have 'such a silly fuss' made.

Since the 1960s, many other museums have acquired Parrish art works, including the Boston Museum of Fine Arts, Harvard University's Fogg Art Museum, the Brandywine River Museum, the Cleveland Museum of Art, the Delaware Art Museum, the Detroit Art Institute, the Philadelphia Museum of Art and many others. In more recent years there have been a number of exhibitions of Maxfield Parrish art works, including those mounted by the American Illustrators Gallery in New York City.

Today, the illustrations of Maxfield Parrish, J.C. Leyendecker, N.C. Wyeth, Norman Rockwell and others grace the covers of American painting auction catalogues at Christie's, Phillips', and Sotheby's. They are auctioned on a par with artists such as Cassatt, Bierstadt, Homer, and Sargent.

Until recently, Maxfield Parrish's works have rarely been seen in their original form or even displayed as works of art in galleries or museums, and there are several reasons:

1). Few MP original art works are extant. Unlike the prolific Pablo Picasso, who created over 15,000 works, MP labored over each piece in the age-old fashion of the Old Masters, with his own time-consuming and exacting process. Parrish ultimately created a mere 850 works altogether, of which only about 400 are currently accounted for. Many works have disappeared as a result of poor stewardship.

2). The remaining works are fragile at best and therefore museums and collectors are reticent to loan them. Most are painted on panel boards and consequently are subjected more readily to flaking and craquelure than paintings on canvas.

3). MP's personal painstaking style of painting, his technique of overlaying single colors and varnishing with glazes between each layer (sometimes 40–60 layers of paint), severely limited the number of commissions which he could undertake.

To actually view Parrish originals is a spiritual experience indeed and the opportunity should never be passed up. The true, pure colors with their vividness and strength are

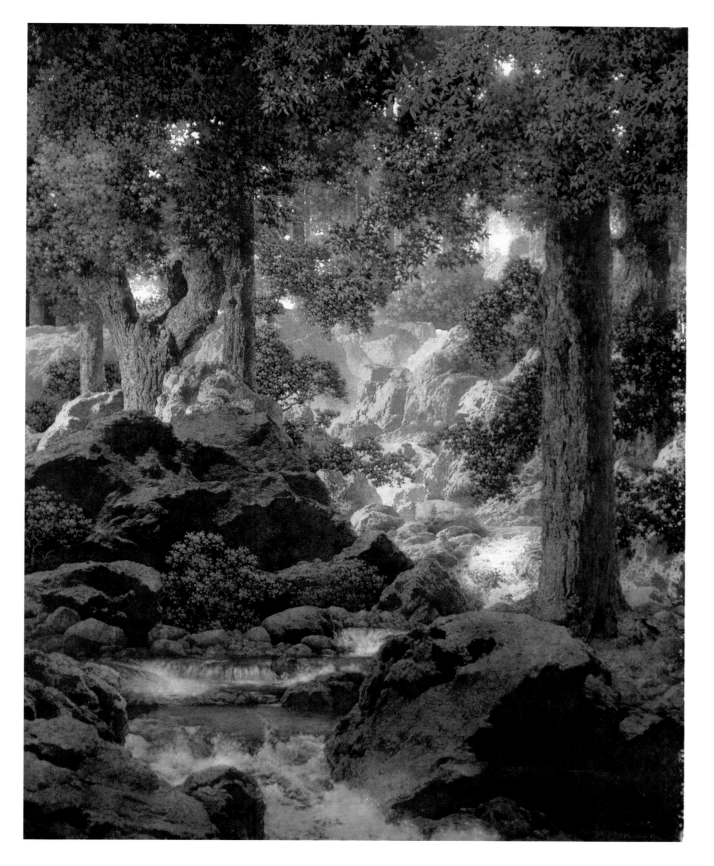

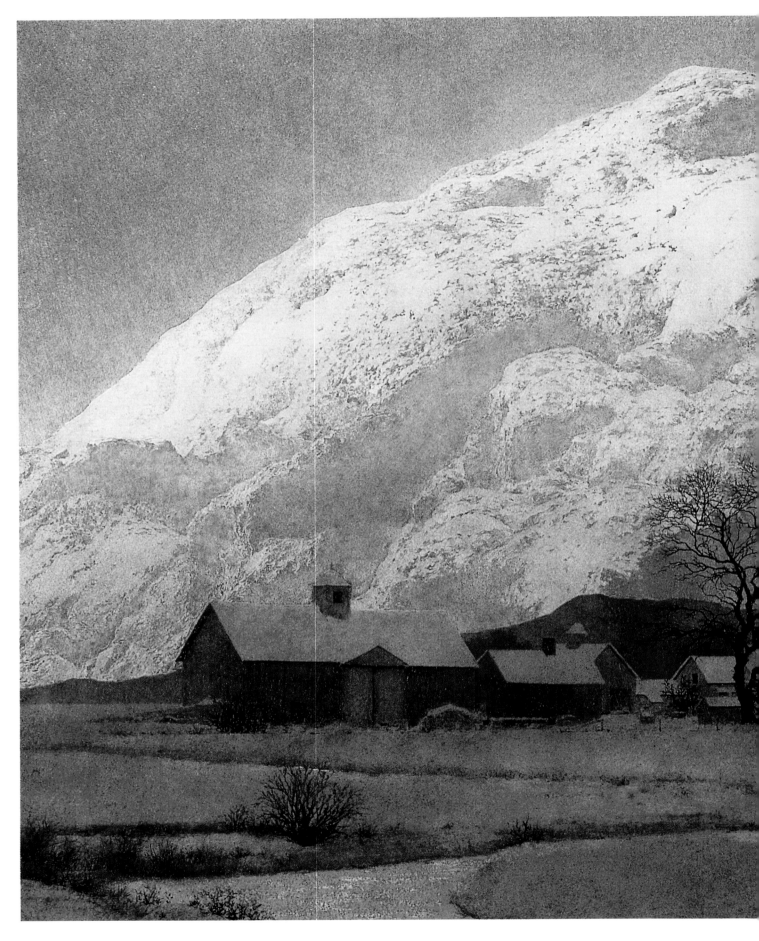

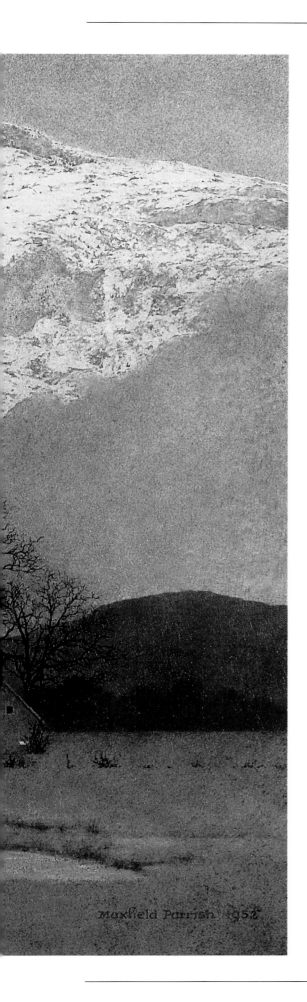

PLATE 47

Hilltop Farm, Winter★ (Lights of Welcome)

1952. Oil on panel, 13¹/₂ x 15¹/₂ inches (34.3 x 39.4cm)
Brown and Bigelow

★(Artist's title)

appreciated far beyond the ability of any printing technology to reproduce them. One of the finest delineators and craftsman with a pen, a stipple brush or a paintbrush, Parrish used photography solely as a means to an end. He did not use photography as a crutch but as a shorthand tool as an alternative to sketching. His true yearning was to get the complicated drawings of fantasy images out of his head as quickly as possible and the camera permitted him to do this. Parrish also had Susan Lewin constantly sewing costumes for particular scenes from history, the theme for a commissioned piece or for an image he described to her from his fertile imagination. Susan, too, played a key role by reinterpreting his verbal images and making them come to life. Max, Jr. jokingly referred to Susan as 'Dad's sewer-upper,' and the grandchildren called her 'Aunt Sue,' but they all knew she was more than a seamstress to 'Granddad.'

THE AMERICAN RENAISSANCE (1875–1917) AND THE MODERN AGE (1918–2000)

The manner in which a person perceives himself influences the way he sees, what he likes and how he creates his own surroundings. What Parrish saw, what he liked, and how he created his art was molded both by his personal background and the cacophonous times. It was indeed a period of intense development for both the evolution of an American

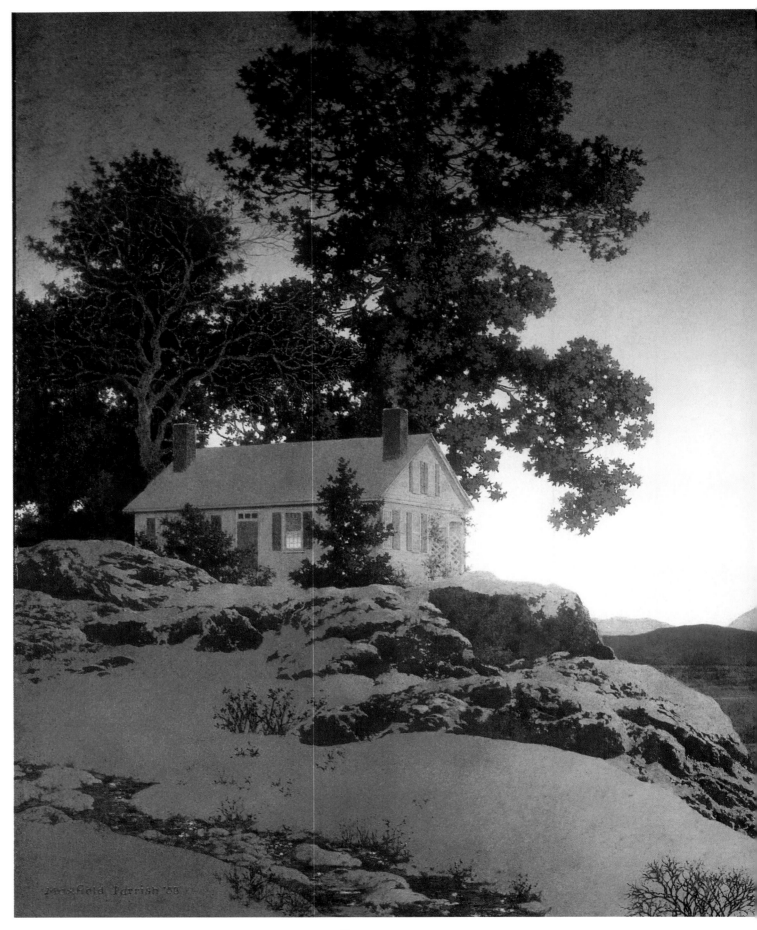

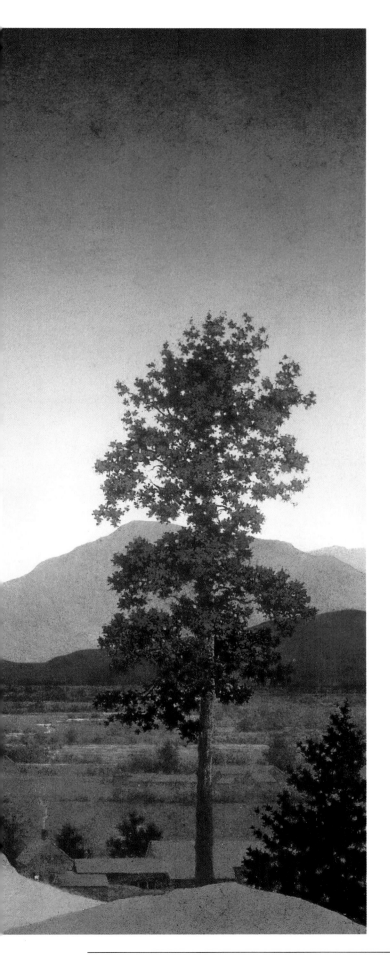

PLATE 48
Evening (Winterscape) 1953
Oil on artist's board, 13½ x 15½ inches (34.3 x 39.4)
Brown & Bigelow executive print, 1956

culture, for the creation of a national identity, and for the evolution of this unique artist. For the first time in American history, artists and architects played the main role in the daunting task of creating what is rightfully called the American Civilization. Augustus Saint-Gaudens audaciously stated, at the planning meeting for the World's Columbian Exposition in 1893, that 'This is the greatest meeting of artists since the fifteenth century.'

THE LAST RENAISSANCE MAN

One must remember that Maxfield Parrish was born in the year during which the transcontinental railroad was completed. His most formative and impressionable years were between 1883 and 1920. It was during those years that the Brooklyn Bridge opened (1883), that Geronimo surrendered his last ragtag band to overwhelming American Army forces (1886), that the first public motion picture was shown in Paris (1894), the first telephone conversation was held (1915), the first transatlantic flight was taken (1919), and of course F. Scott Fitzgerald's novel, *This Side of Paradise* was published (1920). Exciting times to be sure, an exciting era in which to grow up and mature. These were the times when the world was totally redefined and transfigured through technological innovation into the Modern Age.

Interestingly, the artists with the most creative and political influence at that critical time were Parrish's primary associates, his professional colleagues and personal friends. These artists and architects deftly and surgically appropriated elements from ancient European cultures and claimed them for American civilization. Egos enlarged, great concepts became grandiose, and achievable goals became almost unattainable – all exercised within a given framework established by Cornish residents and The Players, these 'creative, cultural forces.' Amidst all of this, Maxfield Parrish made his indelible mark on American civilization.

Maxfield Parrish died quite peacefully in 1966 at his beloved estate, The Oaks, in New Hampshire. Perhaps the last Renaissance man, he lived well into the Modern Age.

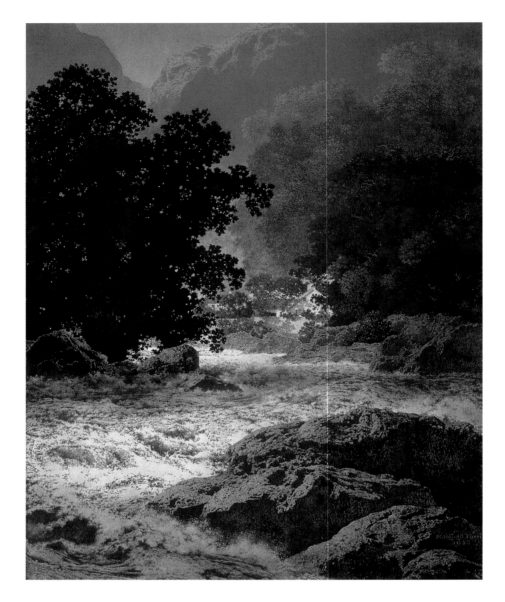

PLATE 49 above
Swift Water (Misty Morn) 1953
Oil on panel, 23 x 18¹/₂ inches (58.4 x 47cm)
Brown and Bigelow calendar, 1956

PLATE 50 right
A Christmas Morning (Winter Sunshine)
1958
Oil on panel, 13¹/₂ x 15¹/₂ inches (34.3 x 39.4cm)
Brown and Bigelow Christmas card

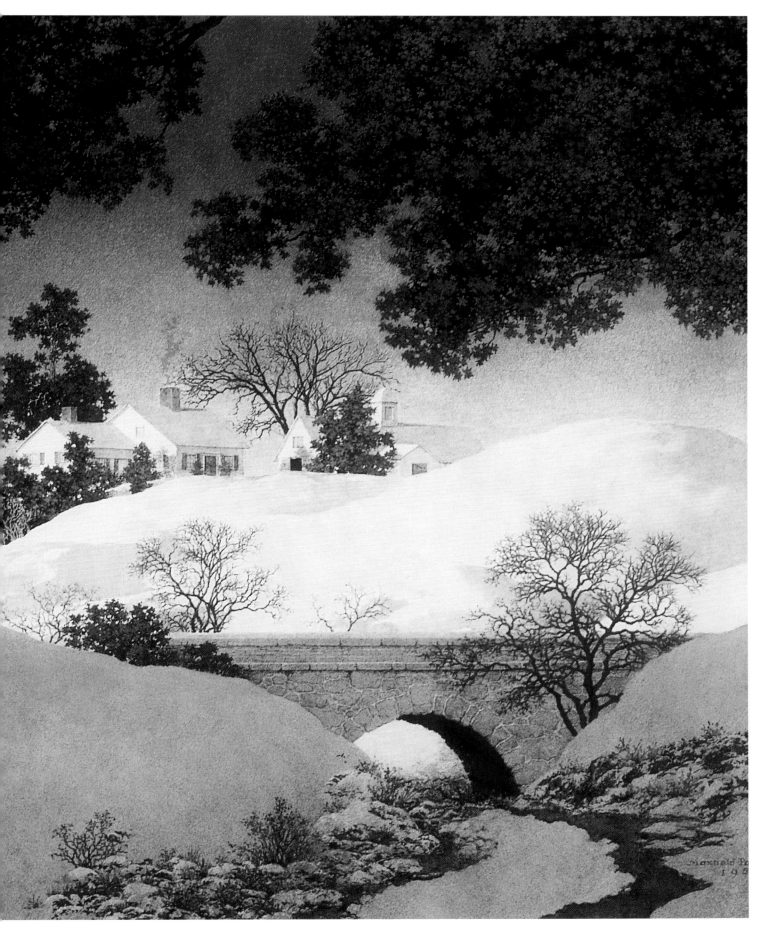

PLATE 51
New Hampshire Summer Landscape
(1958)
Oil on panel, 9 x 11 inches (23 x 27.9cm)

Baum, L. Frank. *Mother Goose in Prose*, Way and Williams, Chicago, 1897.

Colby, Virginia Reed. *Maxfield Parrish in the Beginning*, 1976.

Cutler, Laurence S., and Goffman, Judy. *Maxfield Parrish*, Bison Books Ltd., London, 1993.

Cutler, Laurence S., and Goffman, Judy. *The Great American Illustrators*, The Great American Illustrators Catalogue Committee, Tokyo, 1993.

Cutler, Laurence S., and Cutler, Judy A. G. *Parrish & Poetry*, Pomegranate Artbooks, San Francisco, 1995.

Cutler, Laurence S., and Cutler, Judy A. G. *Maxfield Parrish: A Retrospective*, Pomegranate Artbooks, San Francisco, 1995.

Field, Eugene. *Poems of Childhood*, Charles Scribner's Sons, New York, 1904.

Grahame, Kenneth. *Dream Days*, John Lane: The Bodley Head, London and New York, 1902.

Grahame, Kenneth. 'Its Walls Were As Of Jasper,' Scribner's Magazine, New York, 1897.

Grahame, Kenneth. *The Golden Age*, John Lane, London and New York, 1899.

Hawthorne, Nathaniel. *A Wonder Book of Tanglewood Tales*, Duffield & Company, New York, 1910.

Holland, William and Congdon-Martin, Douglas. *The Collectible Maxfield Parrish*, Schiffer Publishing, Ltd., Atglen, Pennsylvania, 1993.

Irving, Washington. *Knickerbocker's History of New York*, R. H. Russell, New York, 1900.

Jackson, Gabrielle E. *Peterkin*, Duffield & Company, New York, 1912.

Ludwig, Coy. *Maxfield Parrish*, Watson-Guptil Publications, New York, 1973.

Maxfield Parrish Collection, The Quaker Collection, Haverford College, Haverford, 1992.

Meyer, Susan E. *America's Great Illustrators,* Harry N. Abrams, Inc., New York, 1978.

Parrish Family Papers, Dartmouth College Special Collections, Hanover, New Hampshire.

Parrish, Lydia. *Slave Songs of the Georgia Sea Islands*, Creative Age Press Inc., New York, 1942.

Read, Opie. *Bolanyo*, Way & Williams, Chicago, 1897.

Saunders, Louise. *The Knave of Hearts*, The Atlantic Monthly Press, Boston, 1925.

Scudder, Horace E. *The Children's Book*, Houghton Mifflin Company, New York, 1907.

Sunshine, Linda. *The Maxfield Parrish Poster Book*, Harmony Books, New York, 1974.

Wharton, Edith. *Italian Villas and Their Gardens*, The Century Company, New York, 1904.

Wharton, Susanna Parrish. *The Parrish Family (Philadelphia, Pennsylvania)*, George H. Buchanan Company, Philadelphia, 1925.

Wiggin, Kate Douglas and Smith, Nora E. *The Arabian Nights*, Charles Scribner's Sons, New York, 1909.

1870 Frederick Maxfield Parrish (MP) is born in Philadelphia.

1877 MP takes first trip to Europe with parents.

1882 MP completes grammar school in Philadelphia and enters Swarthmore College Preparatory School.

1884 MP leaves on a two-year European trip with his parents where he studies the Old Masters and other classical art.

1888 Enters Haverford College to study architecture and quits during his junior year.

1892 Summers with his father in Gloucester, Massachusetts, at the Annisquam artist colony

Begins formal studies in painting at the Pennsylvania Academy of the Fine Arts.

1893 Summers in Gloucester, Massachusetts at Annisquam.

1895 First commission, a mural for the Mask and Wig Club of the University of Pennsylvania.

Meets Lydia Ambler Austin (1872–1953). They marry on June 1st

1897 MP completes his first illustrated book, L. Frank Baum's *Mother Goose in Prose*.

1898 MP builds his estate 'The Oaks' at Plainfield, New Hampshire.

Century magazine commissions begin and last until 1917.

1903 Commission by *Century* magazine to illustrate Edith Wharton's *Italian Villas and Their Gardens*.

1922 'Daybreak' distributed as an art print by the House of Art. This becomes the most reproduced art image of all time, and secures MP's position as the country's most popular illustrator.

1925 *The Knave of Hearts* by Louise Saunders is published, and is a tremendous success, albeit MP's last illustrated book.

1950 Exhibition at Saint-Gaudens Memorial, Cornish, New Hampshire.

1953 Lydia Austin Parrish dies.

Sporadic retrospective exhibitions – a major show at Dartmouth.

1960 At the age of ninety, MP stops painting due to arthritis in his right hand.

1964 'Maxfield Parrish – A Second Look' exhibition, May 4–26, at Bennington College.

A major exhibition at the Gallery of Modern Art in New York City.

1966 At the age of 95 years, Maxfield Parrish dies.

'Maxfield Parrish – a Retrospect' exhibition held in Springfield, Mass, just months before his passing.

1978 Susan Lewin dies at 88 years of age.

1979 The Oaks is destroyed by fire.

1989 First exhibition since MP's death held at the American Illustrators Gallery, NYC

1993 The 'Great American Illustrators' exhibition curated by Judy A. G. Cutler tours Japan and concludes at the Norman Rockwell Museum.

1995 'Maxfield Parrish: A Retrospective' exhibition, curated by Judy A. G. Cutler, commemorating the 125th anniversary of his birth.

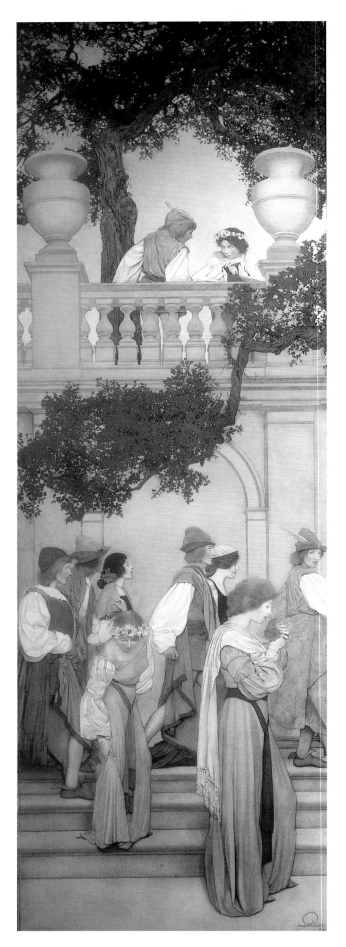

PLATE 52
A Florentine Fete: Love's Pilgrimage
(1911)

Oil on canvas, 126 x 39 inches (320 x 99cm)

Mural for girls' dining room, Curtis Publishing Company,

Philadelphia. (Courtesy The National Museum of American

Illustration, Newport, Rhode Island)